THE TRENCH BOOK

NICK FOULKES

© 2007 Assouline Publishing, Inc.
601 West 26th Street
18th floor
New York, NY 10001
USA
Tel.: 212 989-6810 Fax: 212 647-0005
www.assouline.com

ISBN: 978 2759401 635

THE TRENCH BOOK

NICK FOULKES

ASSOULINE

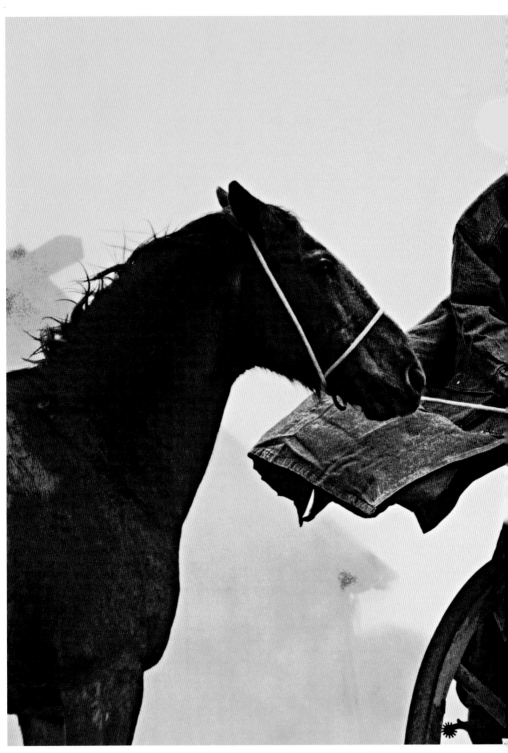

4

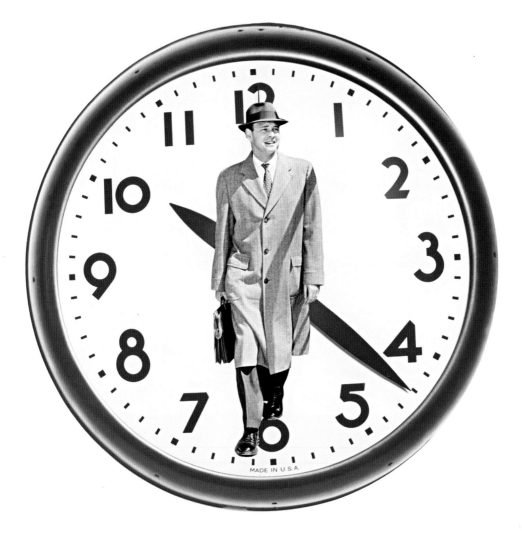

MADE IN U.S.A.

CONTENTS

The history of the trench coat should be a straightforward narrative that begins with the slaughter in the trenches of northern Europe during the early twentieth century and finishes with the garment's early twenty-first century incarnation as the hottest of high-fashion icons—at once seasonal and eternal.

However, to fully understand the trench coat, it has to be set in its context. Rather than being a simple linear narrative with a beginning and end, it is a story that, depending on your view, reaches back in history: the Boer War; the nineteenth and early twentieth century debate about the relative merits of rubberised garments versus those made from closely woven gabardines; the founding of Aquascutum or its rival, Burberry, during the 1850s; and the patent lodged in 1823 by a Scottish chemist for a fabric comprising rubber sandwiched by layers of fabric. Or perhaps to 1627, long before trench warfare, Macintosh, Aquascutum, or Burberry—a time when the coat itself was a newcomer and the outer garment of

choice was the mantle—when John Jasper Wolfden came up with a way of treating "certaine stuffes and skynes to hold out ye wette and ye rayne."[1]

The thing is, the trench coat is much more than an outer garment. It defies simple classification. Is it to be assessed on its rain-repellent merits? Or is it defined by its militaristic architecture, which lends it the distinctive swaggering silhouette that has ensured its survival beyond the Treaty of Versailles, with which it should have been laid to rest in 1919?

Although the trench coat is a British story, it takes those who follow it from the Crimea to the polar wastes, onto the battlefields of the First World War, through the pea-soupers of old London to the film studios of Hollywood, up Mount Everest, and onto the catwalks and runways of the world's fashion capitals.

As it travels around the world, weaving its way into our lives, the trench coat touches us all. It has been worn by hundreds of thousands of troops, from valiant English officers who went "over the top" in

1. Quoted in "The Evolution of Weatherwear," an article in *International Textiles*, 1944, pp. 20–23.

the First World War to Gestapo bullies in the Second; preppies; corporate raiders; beautiful women from Marlene Dietrich to Kate Moss; screen idols from Humphrey Bogart to Brad Pitt; and to you and me.

My first connection with the trench was neither dangerous nor glamorous; we were brought together by a classified advertisement in a local newspaper. While I was at boarding school during the 1970s and 1980s, I used to relieve the tedium of weekends at my particular educational establishment (founded sometime in the mists of the mid-sixteenth century, before even John Jasper Wolfden had discovered how to "hold out ye wette and ye rayne"[2]) by scouring the *West Sussex County Times* for details of jumble sales. Each Saturday, I would ride my bicycle out after lunch, and in the evening return with it dangerously overladen with vintage dinner jackets, ancient suits, and invariably at least one trench coat in some drab shade of grey, fawn, olive, or khaki.

Nor was I alone in my mania for secondhand

2. Quoted in "The Evolution of Weatherwear," an article in *International Textiles,* 1944, pp. 20–23.

trench coats. It seemed that during the seventies and eighties, jumble sales the length of the British Isles were filled with these indestructible coats that had outlived their owners and eventually found their way into charitable sales in church halls and community centres. Here, they were eagerly seized upon by teenagers, drawn by a seductive glamour of the sort of coats worn by dirty old men who exposed themselves in public parks—the trench has always prided itself on broad appeal.

Today, the generation who bought secondhand trench coats—sorry, *vintage*—is now reinventing this historic garment for a new millennium. Wherever and whenever the story of the trench coat began, it is men like Graeme Fidler at Aquascutum, Christopher Bailey at Burberry, and designers like them who are retelling the story of the epaulettes and D-rings, the gun patches and storm flaps, to a new generation.

History

Tracing the ancestry of the trench coat back to its forefathers, one arrives at the coachman's coat of the eighteenth century from which the greatcoat, a more gentrified garment, was derived. In pre-railway Britain, the greatcoat was ubiquitous. And in a similarity to the trench, the architecture of the coat lent it an incidental glamour that men of fashion were quick to exploit. Typical of the style-savvy Regency buck who wore his coat to great effect was Henry Tilney of Jane Austen's *Northanger Abbey*: "The innumerable capes of his greatcoat looked so becomingly important!"[1] gasps the impressionable Catherine Morland. Indeed, there was a vogue in the early nineteenth century for men of fashion to ape the manners and diction of coachmen, even to the extent of having their teeth filed so that they could emulate the piercing whistle, not unlike the "mockney"[2] adopted by the

1. *Northanger Abbey*, Jane Austen
2. Mock cockney accent.

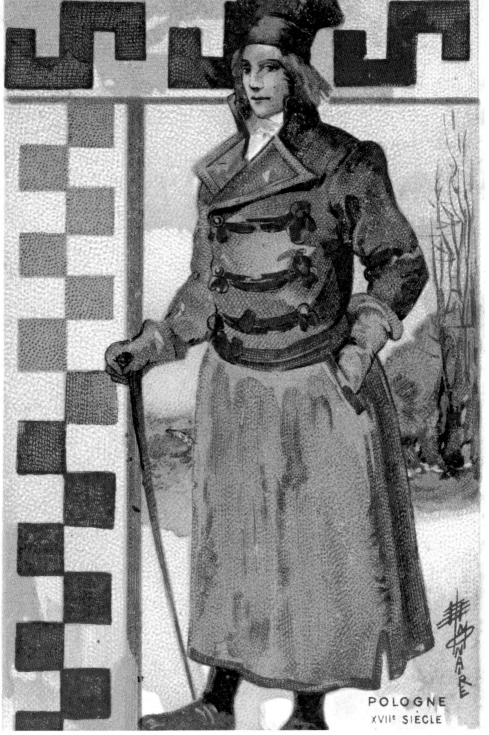

POLOGNE
XVIIᵉ SIÈCLE

13

trustfunded youth of Notting Hill today, trying to deny or disguise their privileged backgrounds.

In common with the trench coat—its distant descendant—the greatcoat was initially conceived as a practical garment, often equipped with numerous capes and collars of heavy woolen cloth piled layer upon layer with the intention of making it difficult for the climate to penetrate to the wearer. Occasionally, the outermost layer of cloth was rubbed with animal oil or grease in a primitive attempt to weatherproof it. However, while the greatcoat might have suited a man of fashion driving his curricle, or a coachman seated atop a mail coach for hours on end, it was cumbersome.

A contemporary website that sells period clothing to "living historians and reenactors of the 18th century" describes its greatcoat, which can be personalized with shorter sleeves and suggested for "Revolutionary War" military use, as "a large overcoat designed to protect the wearer from the worst of the elements. The coat has a collar that can be turned up around the owner's face, and sleeve cuffs

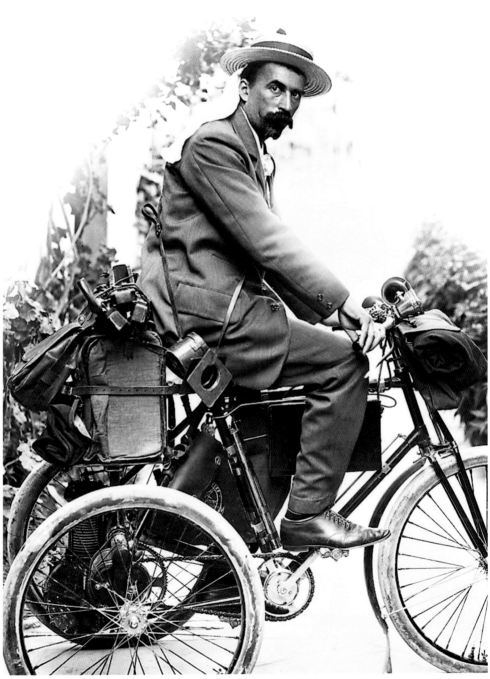

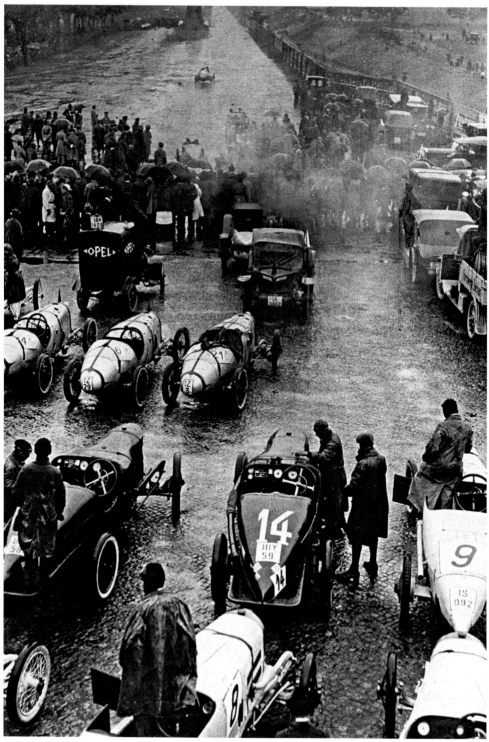

A motor race on Avus circuit, Berlin, 1922

The trench coat is the only thing that has kept its head above water.

Jack Lipman, founder of Drizzle

that can be turned down to protect the hands. Deep pockets also offer a refuge from the cold, or for a corncake or biscuit. A cape adds warmth around the shoulders, and helps to shed rain."

The early years of the nineteenth century were a time of sartorial experimentation. The greatest style leader and fashion arbiter of the time was the Count d'Orsay, a bisexual gambling dandy, artist, sculptor and political fixer. The penniless but drop-dead gorgeous son of a Napoleonic general scandalised society by having an affair with Lord Blessington and then his wife, while also finding the time to marry his daughter. In addition to maintaining a busy social schedule, the count found time to initiate many fashions, and one of the sartorial innovations with which he is credited is the paletot.

The paletot was a significant item of nineteenth-century male dress, as Penelope Byrde explains in *The Male Image, Men's Fashion in Britain 1300–1970:* "The shorter, wider, and more informal coats of the mid nineteenth century were derived from the Paletot, which was originally a 'short greatcoat' but

came to be a general term for any kind of loose outer garment. Its easy cut lay in the absence of a waist seam."[3]

At its most basic, it was nothing more glamorous than a loose-fitting coat worn by mariners. Nevertheless, its impact on the polite dress of the day was huge, as is described by Farid Chenoune in his *A History of Men's Fashion:* "Around 1835 there emerged a fashion that provoked wariness among tailors—the overcoat. Its primary feature was that it did not hug the waist. Rather, it took up where the cloak had left off, since there were no horizontal seams anywhere, nor any pleats under the arms. The overcoat was neither frock coat nor tunic, and a simple overcoat in coarse broadcloth or ratiné fell straight like a sack. Double-breasted, back-vented, firmly buttoned and endowed with large pockets, it had nearly all the features of the sailor's coat that, according to legend, the Comte d'Orsay borrowed one rainy day."[4]

According to one source, the legend surrounding the "invention" of the paletot began when

3. *The Male Image, Men's Fashion in Britain 1300–1970,* Penelope Byrde, p. 134.

d'Orsay, who was out riding, was caught by a sudden downpour and discovered that his groom forgot to bring a suitable outer garment:

"D'Orsay was equal to this as to most occasions. He spied a sailor who wore a long, heavy waistcoat which kept him snug.

'Hullo, friend,' called out d'Orsay, pulling up. 'Would you like to go into that inn and drink to my health until the rain's over?'

The sailor was, naturally enough, somewhat surprised, and asked d'Orsay why he was chaffing him.

'I'm not,' said d'Orsay, dismounting and going into the inn, followed by the sailor, 'but I want your vest. Sell it to me.'

He took out and offered the poor devil ten guineas, assuring him at the same time that he 'could buy another after the rain was over.'

D'Orsay put on the vest over his coat, buttoned it from top to bottom, remounted, and rode on to town.

The rain passed over, the sun came out again,

4. *A History of Men's Fashion,* Farid Chenoune, p. 65.

For students of
the trench coat,
1851 will always be
significant as the year
John Emary opened
a tailor shop
on Regent Street.

Manchester was becoming the rainwear capital of the world.

and as it was the proper hour to show himself in Hyde Park, d'Orsay showed himself.

'How original! How charming! How delicious!' cried the elegant dandies, astonished by d'Orsay's new garment. 'Only a d'Orsay could have thought of such a creation!'

The next day dandies similarly enveloped 'the thing,' and thus the paletot was invented."[5]

Whether one chooses to believe that d'Orsay invented the raincoat in this picturesque way, it is undeniable that shortly after his canter round the park in his impromptu raincoat, a torrent of new overcoat designs flooded onto the market in such numbers that fashion historians of later generations were quite unable to cope with the variety. "During the remainder of the century, overcoat styles continued to be produced with a bewildering number of names, some of which it is no longer possible to identify with accuracy,"[6] complains Byrde.

At about the time that d'Orsay was dazzling the dandies with his witty adoption of the mariner's

5. *WTS*, p. 120.

outer garment, the grimy industrial town of Manchester—not a place that d'Orsay would have cared for—was taking its first tentative steps towards becoming the rainwear capital of the world. Among the advances of the early nineteenth century was the introduction of gas lighting to big cities. In Glasgow, this gas was derived from coal, and one of the waste products was a liquid called coal-tar naphtha. In about 1818, a Scottish chemist named James Syme discovered that this substance was a solvent, capable of dissolving rubber.

He passed his observations on to another Glaswegian, Charles Macintosh, a successful businessman who had made a fortune developing a form of dry bleach. Macintosh began to experiment with the adhesive rubber solution, and by 1823 he had come up with a practical application for the substance. Towards the end of the eighteenth century in the West Indies, there had been instances of garments being coated in rubber latex (apparently, the indigenous peoples had been doing this for years). The substance,

6. *The Male Image, Men's Fashion in Britain 1300–1970*, Penelope Byrde, p. 134.

however, did not travel well. Using naphtha, Macintosh created a spreadable, sticky substance that could be used in the same way. His touch of genius was to sandwich it between two layers of cloth, creating a waterproof fabric that was not sticky and could be made into clothes. The eponymous macintosh (or Mackintosh) had been born. But there was one problem: Macintosh's product stank. If you stood downwind of someone wearing a coat made out of Mr. Macintosh's fabric, you would smell him before you saw him, and the smell would easily be detected on the other side of the street.

Undeterred by the rank reek of the stuff, in 1824 Charles Macintosh & Co. started trading in Manchester. As the so-called Cottonopolis of the United Kingdom, with cotton mills all over town, Manchester promised an abundance of the necessary fabric to act as bread for this rubber sandwich. Although his name was above the gates and on the factory wall, it appears that Macintosh was a sleeping partner, having

assigned his patent to the Birley brothers in return for a third of the profits. Another partner, Thomas Hancock, joined in the 1830s.

In late years, the logo of Macintosh's firm would carry a dozen medals awarded at the international trade fairs that were so much a part of nineteenth-century commercial life. The company boasted of offices as far afield as South America, South Africa, Australia, and New Zealand, and proudly announced itself as "Contractors to the Admiralty, War Office & other Government Departments."[7] However, the preceding rubberised garments were not auspicious. There was some initial success as a novelty and fashion item: the fabric was used on Captain Parry's exhibition to the North Pole. Also, "a waterproof military cloak of blue cloth, lined with crimson silk, had been made for the Duke of York, and the officers of the guards began to wear light drab cambric capes on their way to field exercises, and the other young men as usual following their example, our material (especially of this

7. Documents held at Miami University.

drab colour) began to take with the public generally," Hancock would later recall in his autobiography with the catchy title, *Personal Narrative of the Origin and Progress of the Caoutchouc or India Rubber Manufacture in England.*[8]

But the excitement was soon over. While a macintosh protected the wearer from the rain, the garment was unencumbered by any pretensions to style, making its wearer look like he was dressed in a sack or a poorly made agricultural labourer's smock. By 1836, the fashion was well and truly over, at least according to the *Gentleman's Magazine of Fashion:* "It is impossible to say a word in favour of this freak of fashion, but as it is fast going out, we only observe that no one can look like a gentleman in such a garb and it is of a most unpleasant odour."[9]

Defects and side effects made them unpopular. "The first mackintoshes were heavy; the rubber went rigid in the cold and sticky in the heat. They

8. *Personal Narrative of the Origin and Progress of the Caoutchouc or India Rubber Manufacture in England,* Hancock, Longman, 1857, p. 55, quoted in *Manchester Mackintoshes: A History of the Rubberised Garment Trade in Manchester,* Sarah Levitt, *Textile History,* 17 (I), 1986, p. 52.
9. *Gentleman's Magazine of Fashion,* February 1836, quoted in *Handbook of English Costume in the Nineteenth Century,* p. 142.

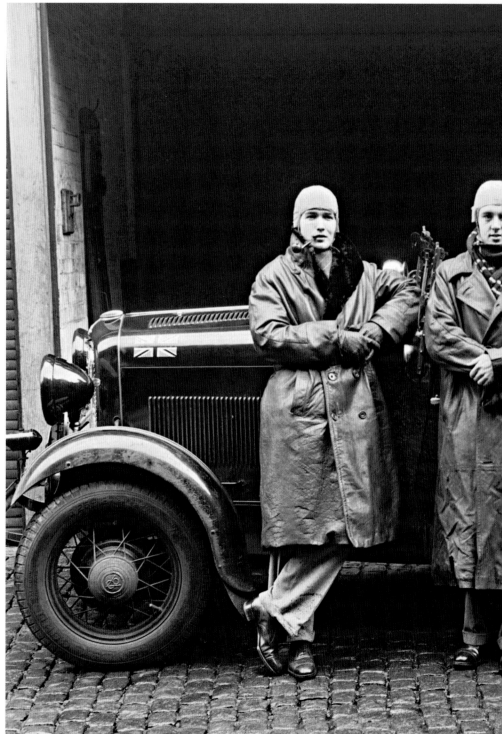

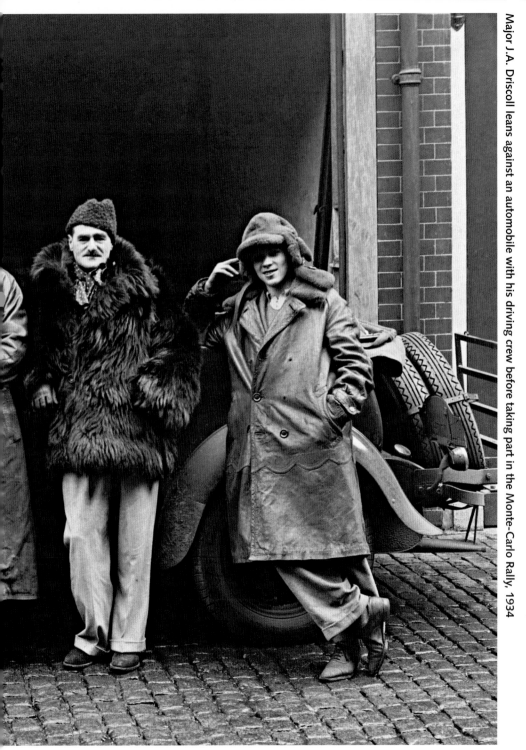

smelt atrocious and, being impervious, made the wearer drip with perspiration."[10] So vile was the stench that by the late 1830s anyone wearing one of these aberrations was having trouble "being admitted into an omnibus on account of the offensive stench which they emit."[11]

Nevertheless, Macintosh's partners persevered. Manufacturing processes improved and the industry overcame the early difficulties of stench, stiffness and stickiness. Business recovered and then boomed, with thousands of workers in Manchester alone being employed in the rubberised garment trade. With vulcanisation, rubberised cloth became less temperature sensitive. Its stability, suppleness and quality improved throughout the remainder of the nineteenth century through the progressive use of such processes as "vapour curing"[12] and "Waddington's dry heat process."[13]

For students of the trench coat, 1851 will always be significant as the year that John Emary

10. *Manchester Mackintoshes: A History of the Rubberised Garment Trade in Manchester*, Sarah Levitt, Textile History, 17 (I), 1986, p. 52.
11. *Gentleman's Magazine of Fashion*, 1839, quoted in *Handbook of English Costume in the Nineteenth Century*, p. 142.
12. *Manchester Mackintoshes: A History of the Rubberised Garment Trade in Manchester*, Sarah Levitt, Textile History, 17 (I), 1986, p. 54.
13. *Op.cit.*, p. 52.

opened a tailor shop on Regent Street, a business that would later carry the name Aquascutum. But the founding of Aquascutum was not the only event of note in that year, which also saw six million people traipse through Hyde Park to visit the Great Exhibition of 1851. The Great Exhibition provided a timely boost to the apparel industry, and the influx of fashion-conscious Jewish tailors fleeing pogroms in mainland Europe to settle in Manchester moved the rubberised cotton business from utility to fashion. And indeed, many of the companies founded by these immigrants survived into the latter half of the twentieth century. By its nature, the manufacture of rubberised garments was specialised work. Conventional tailoring was no good, as water would find its way through the holes made by needles. Tailors trying to overcome this with double rows of stitching just doubled the problem—all seams had to be proofed, and the cloth had to be handled with extreme care. So even if they had not intended to

become clothing manufacturers, manufacturers of the fabric soon developed a capacity to make finished garments as well.

While the business may have been profitable for the owners, it was not without its hazards for the workers. Not uncommonly, a sheet of fabric would burst into flames during the treatment process, and often times the flames spread to other bolts of cloth. With the use of the highly flammable coal-tar naphtha as a solvent, the consequences could be disastrous. Throughout the century, various Manchester factories erupted into flames. In 1838, when a big vat of naphtha on the top storey of a factory caught fire, the flaming tide that cascaded through the lower floors caused the building to collapse, costing five workers their lives.

Nor was fire the only danger. Solvent abuse is a well-documented social ill of modern times, and in nineteenth century Manchester, it was an occupational hazard. " The odour of naphtha is so strong as to be distressing for some time to those who have weak or irritable lungs," recorded a reporter visiting

Macintosh's works, who asked one of the workers if he ever suffered from the odour. He answered that "the only ill effect he ever experienced was occasionally several of the symptoms of intoxication, and now and then the occurrence of intense headaches. He assured us that after a busy day in his part of the factory, he no sooner emerged into the fresh air than he commenced staggering and reeling as if under the potent influence of ardent spirits."[14] Hallucination was a frequent problem: "Rubber workers running round flapping their arms and trying to fly were not an uncommon sight."[15] Others experienced tingling and numbness in their limbs. However, there was a lighter side. One worker remembered that "it was the custom for some girls working in some of the departments to light the various gas jets at dusk by the simple expedient of dipping their fingers into a can of rubber solution, lighting it, and going the round of jets."[16]

14. *Sharples Magazine,* quoted in *Manchester Mackintoshes: A History of the Rubberised Garment Trade in Manchester,* Sarah Levitt, Textile History, 17 (I), 1986, p. 52.
15. *Manchester Mackintoshes: A History of the Rubberised Garment Trade in Manchester,* Sarah Levitt, Textile History, 17 (I), 1986, p. 55.
16. G. Bohanna, "Recollections of 50 Years in the Rubber Industry," quoted in *Manchester Mackintoshes: A History of the Rubberised Garment Trade in Manchester,* Sarah Levitt, Textile History, 17 (I), 1986, p. 55.

And while the workers of Manchester's rubber industry were setting fire to their hands, flapping their arms thinking they could fly, staggering home drunkenly after a day inhaling naphtha fumes, losing the use of their arms and legs, or losing their lives in flash conflagrations, the quality of rubberised garments was definitely improving. In contrast with the heavy, creaking, foul-smelling, temperature-sensitive coats of the early years, waterproof coats had become light, practical and even fashionable. Typical of these were Hellewell's waterproof five-ounce weight reversible paletot.

"Can be carried in a coat sleeve or pocket and folded up in the space of a cigar case!" ran an 1854 advertisement. "The lightest, best and most portable protection from the rain and dust, adapted for fishing, rowing, yachting, riding, driving, hunting, shooting, coursing, deerstalking, etc."[17]

This miraculous, polymath garment and countless others seemed to rule supreme, unassailed by any competition. But even as the rubberised

17. Advertisment in the Manchester Post Office Directory, 1854, quoted in *Manchester Mackintoshes: A History of the Rubberised Garment Trade in Manchester,* Sarah Levitt, Textile History, 17 (I), 1986, p. 53.

garment trade of Manchester soared to its zenith, its downfall was being plotted by two men from the south of England.

In 1851, John Emary opened a tailor shop on Regent Street. A couple of years later, he perfected a process for creating a rainproof cloth and called it Aquascutum (literally, "rain shield," from the Latin *aqua* for water and *scutum* meaning shield).

Five years later, the market town of Basingstoke saw the opening of a draper's shop by a 21-year-old apprentice. Having grown up in the country, he was familiar with the linen smocks worn by farm workers; he noticed how their easy construction did not impede movement, how they were warm in winter and cool in summer, and how, even though they were breathable, they were shower resistant (as it dampened, the cloth shrank and the weave became tighter). This young man wanted to transfer these qualities to overcoats and other items of sporting and formal wear. His name was Thomas Burberry.

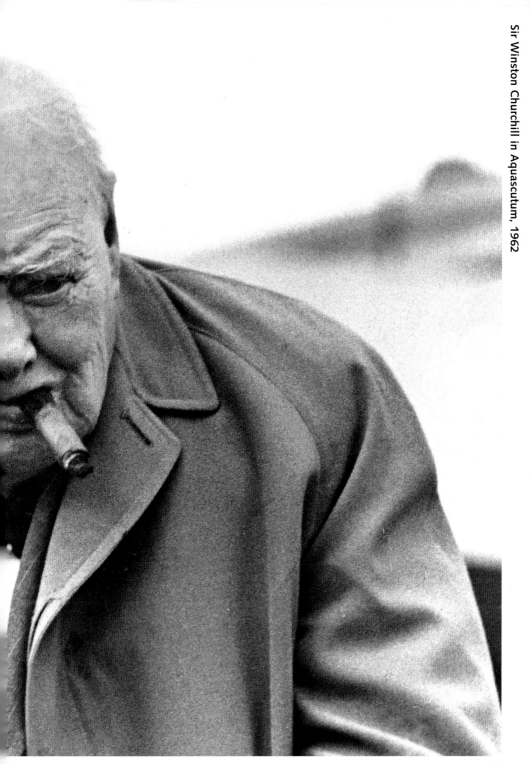

MYTHOLOGY

An Icon Deconstructed: What Makes a Trench a Trench

The trench was not invented. Its basic architecture evolved out of utility and practicality: to protect against the weather, or otherwise serve its wearer in the inhospitable environment of the trenches. Each of its defining features can be linked with a function, rather than a whim of the tailor or the clothing designer.

One of the keystones of the trench is the raglan sleeve, which made its debut in the nineteenth century. During that era, it seemed that every fashion trend had an aristocrat to go with it, and it was the first Baron Raglan who gave his name to the style of sleeve that reaches to the neckline, covers the entire shoulder, and is characterised by a diagonal seam across

Her Majesty Elizabeth II

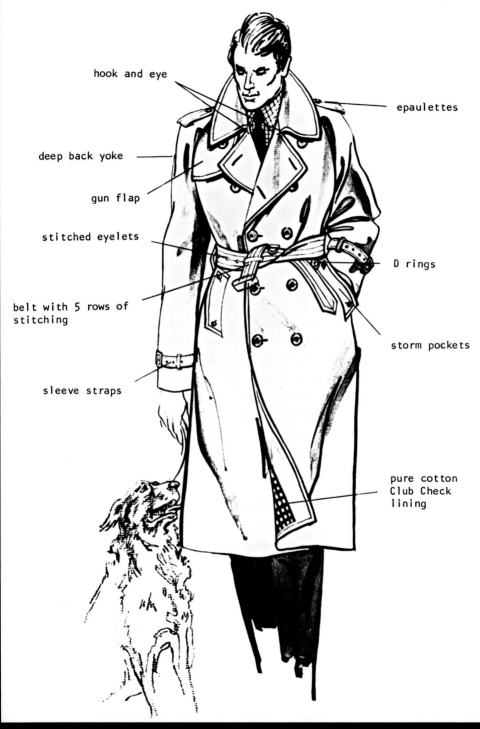

hook and eye

epaulettes

deep back yoke

gun flap

stitched eyelets

D rings

belt with 5 rows of stitching

sleeve straps

storm pockets

pure cotton Club Check lining

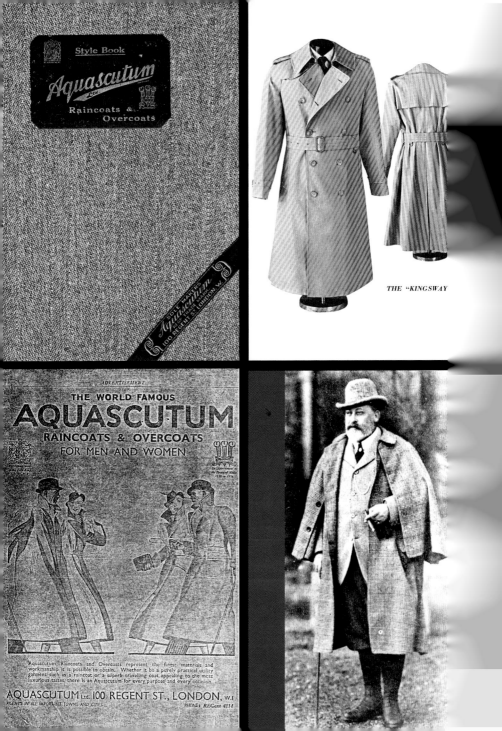

Style Book

Aquascutum

Raincoats &
Overcoats

THE "KINGSWAY"

the front of the garment. Lord Raglan had lost an arm at the battle of Waterloo (his elbow had been shattered by a musket ball, and doctors amputated rather than risk infection.) Such was his stoicism during the operation tha someone nearby realised that his arm had been removed only when he raised his voice to say, "Hey, bring my arm back. Thee's a ring my wife gave me on the finger."

The widely accepted version of the birth of the eponymous sleeve is that Raglan's tailor devised it in order to make it easier for Lord Raglan to dress himself. Anyone who has worn a raglan-sleeved coat knows that it simply shrugs on and off rather than needing to be got into. Raglan sleeves also appear on all sorts of sportswear, thanks to the increased ease of movement allowed by the unique cut...

However, there is an alternative and a more picturesque version of the sleeve's genesis, which is told by Graeme Fidler, "Legend traces this design back to the first Baron Raglan, hero of the Crimean War, who, to help soldiers keep warm, devised a garment made from a potato sack slit at the neck and slashed diagonally across the corners to allow the arms to swing free. This diagonal opening forms the basis for the raglan sleeve design and its comfortable, easy cut."

Whether it came from a sack of potatoes or an aristocrat's tailor, the raglan sleeve (or shoulder) became popular in the 1850s, and its ease of wear meant it was perfect for basic construction of the trench coat. The seams of the raglan sleeve run across the front of the classic trench.

Pages 42-43:
Cary Grant in
his Aquascutum
coat visiting the
Montreal store,
1955

Previous pages:
Left: An
Aquascutum
design sketch
detailing trench
essentials,1980.

Right: (clockwise)
Cover of the
Aquascutum
"Style Book,"
1930s,
Advert for the
Aquascutum
Kingsway coat,
1950,
HM King Edward
VII in his
Aquascutum cape,
1903,
Stylish Art Deco
images were used
for this
Aquascutum
advert, 1939.

The man
in the trench coat
Badge out, laid off
Says he's got
a bad cough
Wants to get it
paid off.

"Subterranean Homesick Blues"
Bob Dylan

Other classic identifiers are welted pockets, two rows of ten buttons in all down the front of the coat, and a storm flap at the shoulder, under which the lapel can be buttoned in inclement weather. A hook and eye arrangement closes the coat at the neck, while the collar can be raised to cover the chin and secured using a strap and buckle system called a throat latch. Further weather tightness is assured at the wrist by another strap and buckle.

The belt at the waist is equipped with D-rings, which were originally used to suspend items of equipment, grenades, or swords, although by the time the trench coat appeared the sword was ceremonial in use. The shoulder straps, or epaulettes, were used to secure shoulder-slung items such as binoculars, gas masks, and whistles, or to hold gloves—another functional element not to be forgotten amidst contemporary interpretations laden with such elaborate details as gold-threaded top stitching, woollen checked trims, and delicate leather fabrics.

Opposite:
Lizabeth Scott
wearing an
Aquascutum
Queensway coat
in the film, *Stolen
Face*, 1952.

Following pages:
Right:
The Invisible
Businessman.

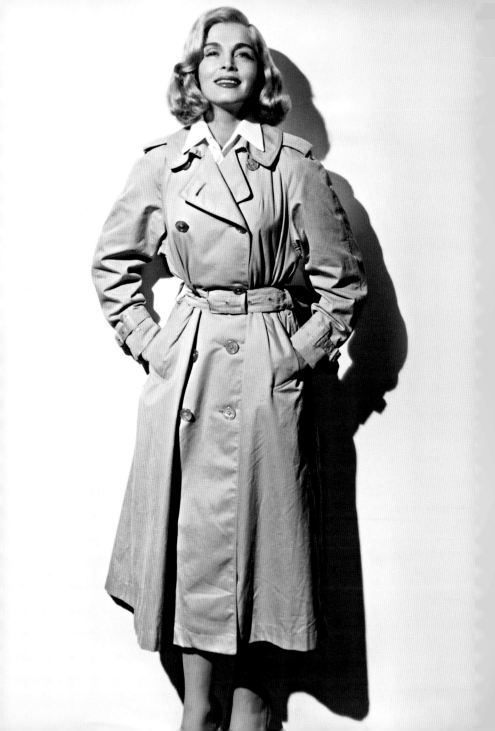

The trench was not invented. It evolved out of utility and practicality.

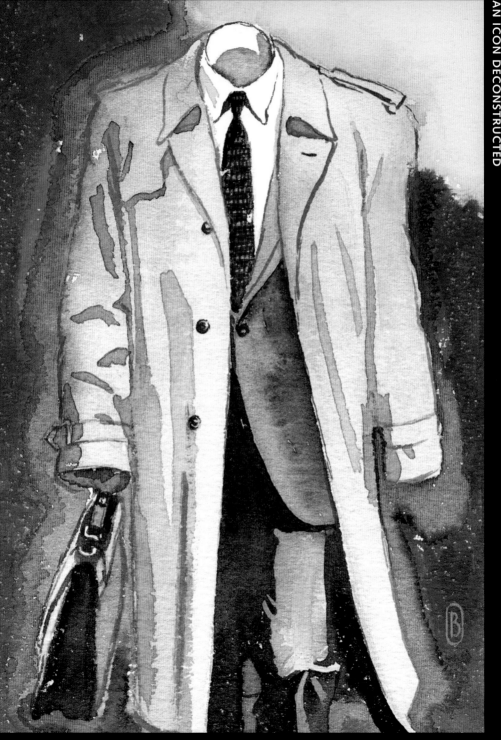

The Trenches

After the Battle of the Marne in September 1914, General Erich von Falkenhayn ordered the German army to withdraw to the River Aisne and to dig itself in there, creating a defensible position from which it could protect the territorial gains made following the German invasion of the Low Countries and France. Very soon the whole western front, almost 500 miles from the North Sea to Switzerland, was characterised by opposing sets of trenches that would give the Great War its unique and terrible character for the ensuing four years.

Trench warfare was a consequence of the industrialised nature of battle: larger armies and increasingly rapid, accurate and deadly weapons. For instance, the Gatling gun militated against the deployment of bodies of troops and the use of mounted shock troops charging in close order. Where once battles had been fluid, they began to

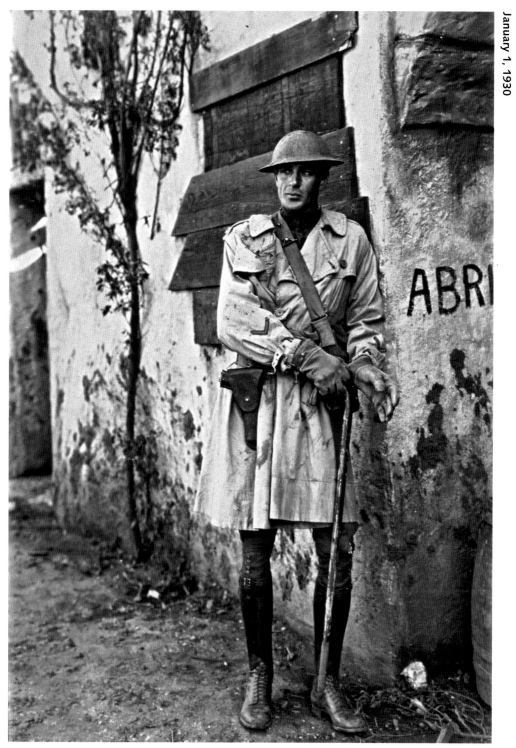

Photographer Irving Penn in his American Field Service uniform (belted trench coat and cap), ca. 1945

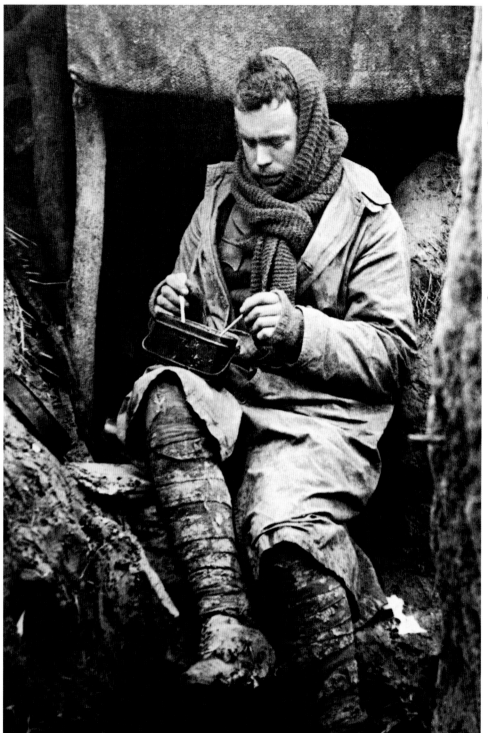

A British soldier eating his dinner in the trenches during World War I, ca. 1917

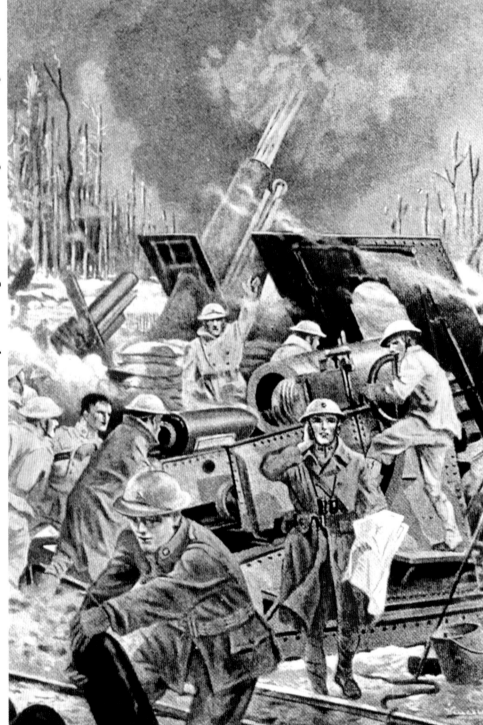

American artillery bombarding German forces with gas bombs during the Great War

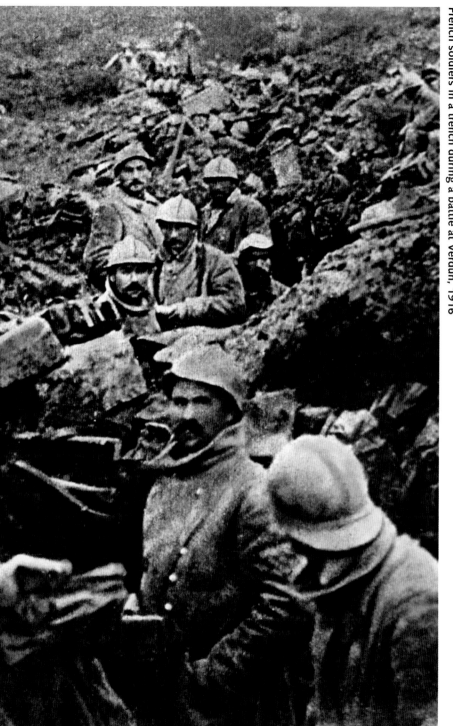

French soldiers in a trench during a battle at Verdun, 1916

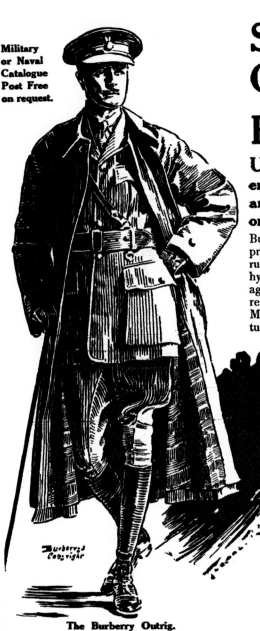

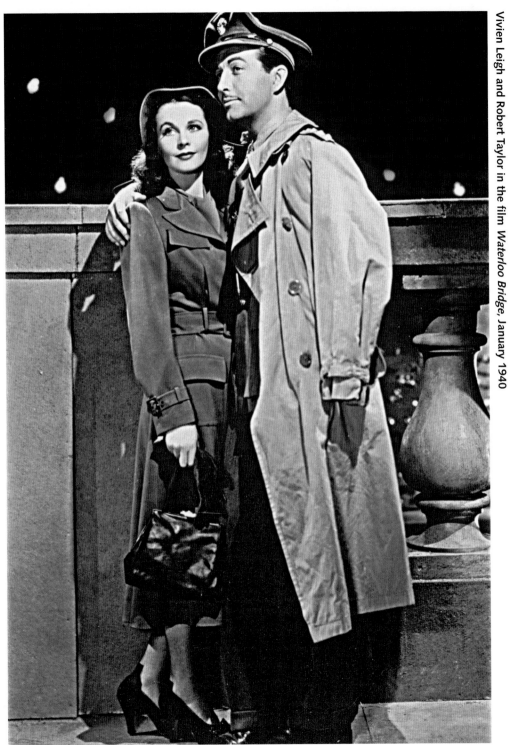

become more static affairs. Trenches first appeared in the American Civil War of 1861–1865 and were used at the turn of the century in the Boer War and during the Russo-Japanese War of 1904–1905. But it was during the First World War, involving millions of men as well as the financial and technical resources of the most civilised and advanced nations (if slaughter on such a scale can be carried out by civilised nations) that trench warfare came of age—achieving almost scientific status as a fully developed military discipline.

Times had moved on since the primitive ditches from which the Boers had fired their Mausers. The trenches of the First World War had their own construction techniques and were more than mere straight tracks gouged out of the ground. They were specially designed with twists, turns, and doglegs so that an enemy seizing a part of the trench could not enfilade a whole trench. There were communication trenches, supply trenches, forward observation trenches, reserve trenches, embrasures, firing points, and a German

specialty—concrete-lined shelters located deep underground.

The Germans chose the better positions on the higher ground by digging in first, leaving the French and British the waterlogged lowlands. With a few small variations in position (achieved at a cost of lives calculated in hundreds of thousands), that is how they remained for most of the rest of the war: four long years of death, disfigurement, damp, disease, boredom, fear, mud—and trench coats.

However, the military life of the rubber-free ventile coat predates even trench warfare. In 1853, John Emary had just perfected his riposte to the rubberised garment and changed the name of his company to Aquascutum to advertise the coat's water-repellent properties. His breakthrough came just in time for the Crimean War.

From a political and military point of view this war—fought a long distance from Britain with the French and Turks as allies against the Russians— was a fiasco. Incompetence, disease, and logistical problems made it an armed excursion that the

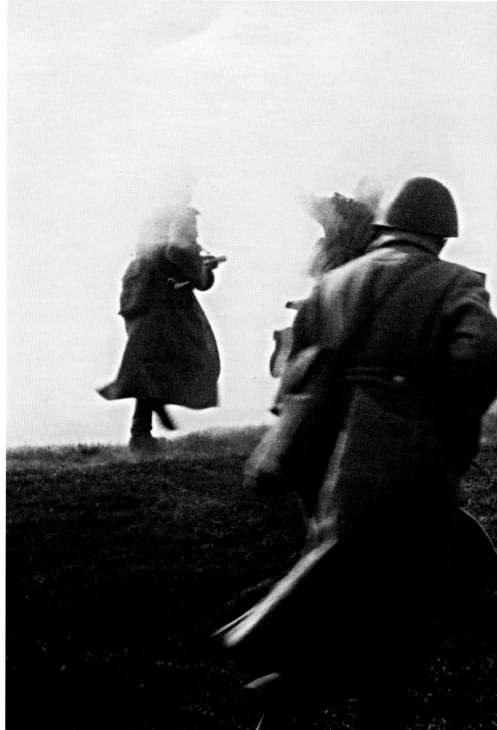

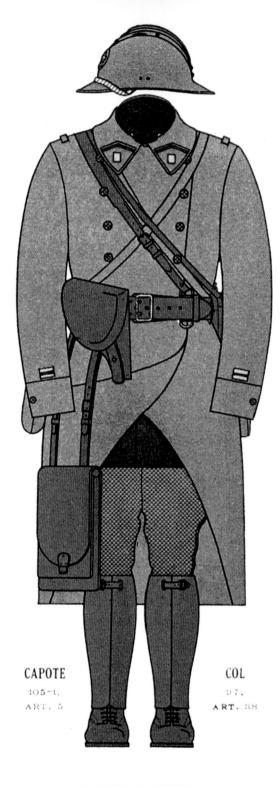

CAPOTE COL

405-1. 97.

ART. 5 ART. 38

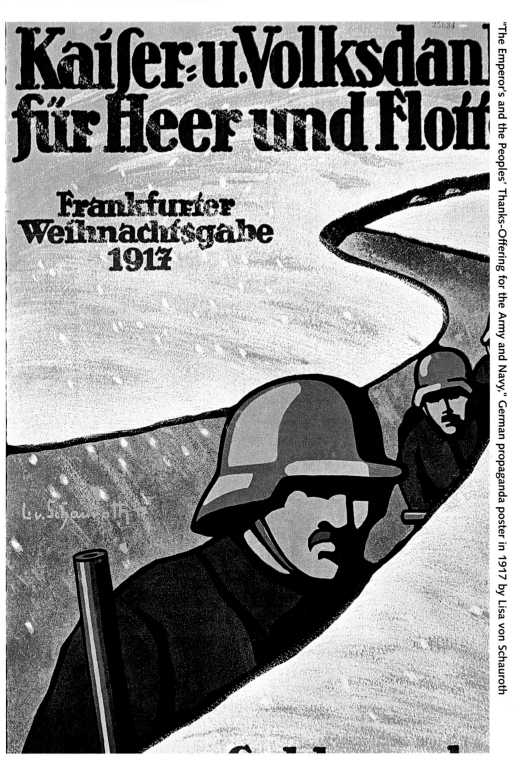

Kaifer=u.Volksdan
für Heer und Flott

Frankfurter
Weihnachtsgabe
1917

"The Emperor's and the Peoples' Thanks-Offering for the Army and Navy," German propaganda poster in 1917 by Lisa von Schauroth

British would rather forget. But for Emary, it provided a major publicity coup. He supplied overcoats in his miraculous new fabric to some of those who fought, and one officer was able to thank Aquascutum for saving his life. The story is told in a document in the Aquascutum archives.

"Lt. General Goodlake, one of the first men to receive a V.C., served through the whole of the Crimean War. He helped to raise, and later commanded, a small force of sharpshooters who took part in a series of exciting and dangerous guerrilla actions. On one of these, he and a sergeant had left their men while they examined some caves on the other side of a ravine. Suddenly a large force of Russians appeared, cutting them off from their group. Goodlake and the sergeant each fired a shot, clubbed the nearest attackers and ran down into the ravine, now filled with the enemy. To their surprise, no attention was paid to them, and they realised that owing to the grey coats they were wearing, they were mistaken for Russians. So they marched

along in the enemy's ranks until they came up with their men, whom they rejoined."

"The grey coat worn by the then Captain Goodlake has been preserved with other relics of the Crimean War at Newstead Abbey. It is interesting that this coat is a Scutum, made by Aquascutum in 1854, more than one hundred and five years ago."

It appears that this account was written in around 1960, when the Cold War was at its height and Russia was once again the enemy.

"The material is a showerproof all-wool cloth. Styles may have changed, but today Aquascutum still makes showerproof Scutum coats as successful at their job as that of the General," boasts an article on "How an Aquascutum Coat Fooled the Russians," from the company's archives.[1]

By the 1870s, Emary had competition in the showerproof market from Burberry, the Basingstoke draper, who had launched his own rubber-free, water-resistant cloth woven from long staple Egyptian cotton, proofed in the yarn, and then proofed again when

1. Aquascutum Advertisement "How an Aquascutum Coat Fooled the Russians," ca. 1960.

Mail-order catalogue of Manufrance (based in Saint Etienne, France) dating from 1931, selling hunting and fishing items

John Emary supplied overcoats in his miraculous new fabric to some of those who fought, and one officer was able to thank Aquascutum for saving his life.

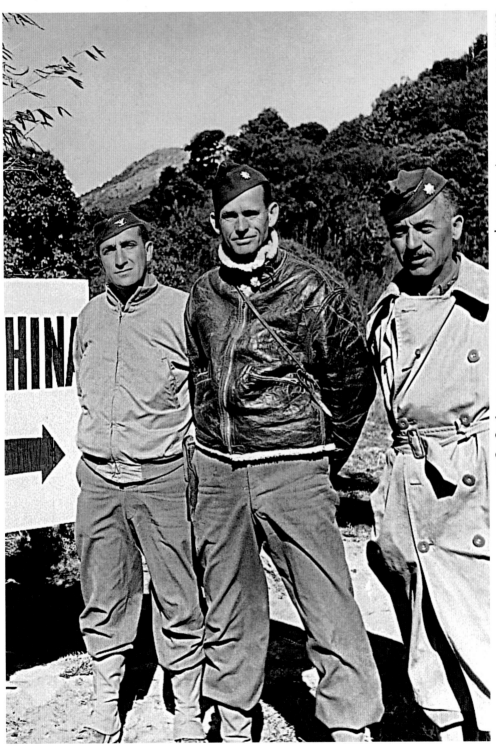

General Claire Lee Chennault, whose troops were known from 1941 as the Flying Tigers

Charles Lindbergh in a leather flying suit, 1928

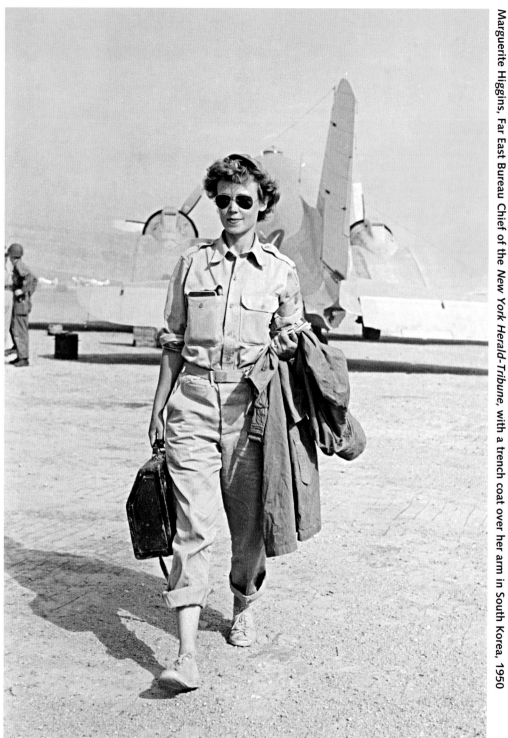

Marguerite Higgins, Far East Bureau Chief of the *New York Herald-Tribune*, with a trench coat over her arm in South Korea, 1950

See the Aquascutum label is in your coat.

"I should like to say that your coat has given every satisfaction, and has proved itself thoroughly waterproof on every occasion."

Capt. A. R,

"I have used one out here for nearly six months, and though it is now very shabby, it is still quite proof against any rain."

Lt.-Col. T. L.

Lockerbie Coat, price 4 Guineas.

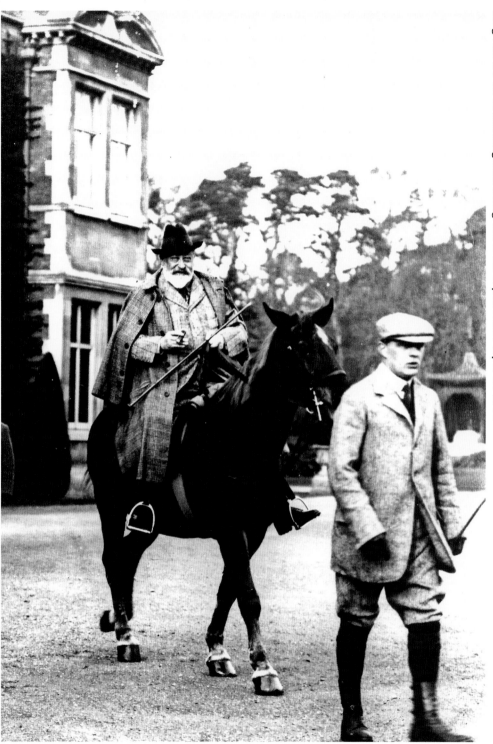

woven into a piece. He called it Gabardine, a term that had been used in the sixteenth century but had fallen from popular use, and in 1879 he registered it as a trademark.[2]

Thereafter gabardine (or gaberdine, as it is sometimes spelled) was used by explorers, hunters, travellers, soldiers, and civilians who all testified to its near miraculous qualities—its watertightness, warmth, lightness, and durability. Amundsen wore an anorak and trousers of Burberry gabardine for his jaunt to the South Pole where he erected a tent also in Burberry gabardine; Sir Ernest Shackleton, C.V.O., also wore it, and so celebrated was Captain Scott's Burberry tent that it went on exhibition in London.

Given its versatility and durability, the fabric was much used during the Boer War. So when veterans of that conflict marched to the trenches in the First World War, they were already familiar with the gabardine coat. The most famous of these was Field Marshal Lord "Your Country Needs You!" Kitchener, K.G., K.P. Following his hasty appointment as

2. It remained a Burberry trademark until 1917.

secretary of state for war in 1914, Kitchener faced the task of raising armies to fight this new war.

Although Kitchener is now largely discredited, at the outbreak of World War One he was an inspiring, reassuring and very British figure. He was the living personification of the British Empire at the zenith of its power: he had put down the Sudanese separatist rebellion of 1898 and had retaken Khartoum. As commander in chief during the Boer War, he pursued a brutal policy of total war, burning Boer farms and imprisoning families in concentration camps, eventually winning this hard-fought conflict. By 1914 he was serving as proconsul of Egypt, was ruling the Sudan, and was the most famous and revered soldier in the British Empire. It was natural that his country would turn to him in a time of peril, and at the outbreak of the war he accepted, albeit reluctantly, the post of minister of war. His military bearing was enhanced by a bristling moustache and a robust trench coat. The model he favoured was the Tielocken. Patented in 1912 and described as a "coat, with straps and engaging

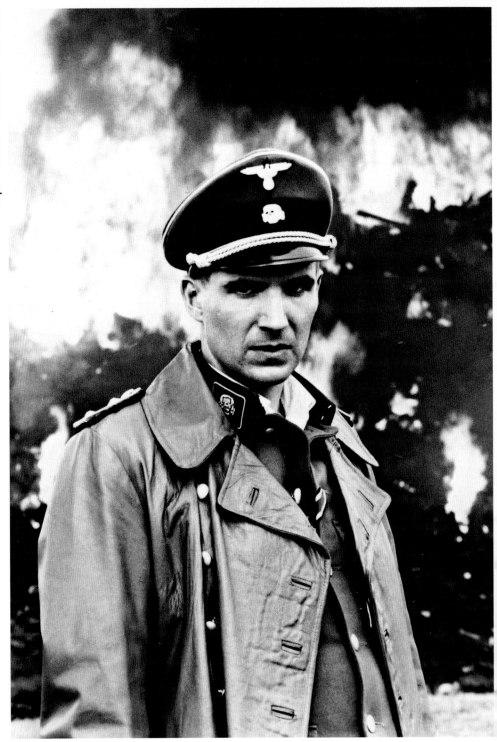

device,"[3] the Tielocken fastened using a strap and buckle rather than buttons, and it quickly became popular with officers who wanted to emulate their leader and enjoy the practicality of this garment.

Like many of those who followed him in his choice of trench coat, Kitchener lost his life during the war. He drowned in 1916, when the ship on which he was travelling to Russia to attend a conference with the tsar, sank off the Orkneys. However, at least he was properly dressed when he met his maker. Coracias Garrulus, the pseudonymous author of a florid promotional booklet issued by Burberry between the wars, reassures his readers that "when last seen standing by the bulwarks of the doomed *Hampshire,* with those steadfast eyes of steel...gazing calmly beyond the tumultuous seas that surged our northern Peloponnesus at the looming horizon of Eternity, Lord Kitchener was wearing his favourite, somewhat shabby, Burberry coat."[4]

But the Tielocken was just one of a panoply of patterns of trench coat favoured by officers over officially supplied garments. Both Burberry and

3. Victoria and Albert Museum, *The Burberry Story,* 1989.

Aquascutum aimed at the style-conscious officer, with Aquascutum promising that any officer who found that his coat leaked could claim a complimentary replacement. However, rather than being bombarded with complaints, Aquascutum frequently received encomia from the front line. Typical was a letter dated May 24, 1916:

"Received coat safely and am quite pleased with it. If it keeps out the wet as thoroughly as my old one, I shall be more than satisfied. I am sending my old one to be cleaned and pressed: it kept out the rain during the blizzard of 26th November at Suvla Bay, and a more thorough test I cannot conceive. Let me have it back as soon as possible." Capt. M.A."[5]

Indeed, so delighted was Aquascutum with its letters from the front that it incorporated them in its advertising, doubtless relishing the opinion of one correspondent who wrote on August 29, 1916, "I received a coat about $3^1/_2$ months ago from you, and I may say I have tried it in all weathers in the trenches, and have never had one damp tunic

4. Coracias Garrulus, *Open Spaces,* p. 81.
5. Advertisement in "Aquascutum Service Kit" 1916, p. 4.

since I received it. I have tried four different coats since I came out here, and yours has been the only satisfactory one in all the four."[6]

It was also important that as well as keeping warm and dry, the officers of His Majesty's Armed Forces were smartly turned out and the trench coat looked great. It may sound fatuous, but the British army at that time maintained many nineteenth century attitudes; among them the cult of the aristocratic "officer class," one of the duties of which was elegance.

On the morning of the Battle of the Somme in the summer of 1916, officers were punctilious in their toilette. Their batmen brought them hot water with which to shave, and they adjusted uniforms "still conspicuously different from the soldiers'"[7] to make sure that they looked their best before going over the top. Some went to great lengths to be certain that they struck the right sartorial note; one officer even "put on his silver spurs for the occasion, and his soldier servant gave him 'a final brush.'"[8] To complete the look, they carried silver-topped

6. Advertisement in "Aquascutum Service Kit" 1916, p. 7

swagger sticks and elegant canes, some eschew-
ing any sort of weapon, even a revolver, because
they considered it un-officerly to get involved in
the actual killing of the enemy; that was a job for
the other ranks. Besides, a weapon would spoil the
line of their splendid bespoke uniforms.

It was the First World War officers' attention to style
as much as practicality that ensured the trench
coat would look good—in addition to wearing well
—for generations to come.

7. *The Face of Battle*, John Keegan, 1976, p. 239.
8. *Op.cit.*

I received a coat about 3¹/₂ months ago from you, and I may say I have tried it in all weathers in the trenches, and have never had one damp tunic since I received it.

Lt. H.G. at B.E.F. in a letter to Aquascutum,

August 29,1916

War Babies

War is hell, but in fashion terms it can be a bonanza. The Crimean War was just such a conflict. It is forever associated with the must-haves of terrorists, assassins, bank robbers, and muggers: the balaclava helmet (first knitted to keep soldiers warm in the cruel Crimean winters); the cardigan (the knitted garment named after the controversial earl who led the Charge of the Light Brigade); and the raglan sleeve, an integral part of the trench coat and, of course, the story of Aquascutum.

Another style to emerge from the trenches was the canadienne, described in Farid Chenoune's *History of Men's Fashion* as "a rustic goat-skin garment imported from Canada during the 1914–1918 war to fight off cold and damp in the trenches. Once peace returned, it survived in the French countryside only to resurface on the backs of workers, zazous, and members of the Resistance during the 1939–1945 conflict."[1] It continued to be worn and reinterpreted until the 1950s.

During the Second World War, Field Marshal Montgomery did for the hooded, patch-pocketed, toggle-fastening duffel coat what Lord Kitchener had done for the trench in the First World War. After the cessation of hostilities, the style remained a hit with existentialist Left Bankers, as well as Campaign for Nuclear Disarmament protestors.

The wristwatch, too, has its roots in war. As long ago as 1880, Constant Girard of the eponymous Girard-Perregaux made 2,000 wristwatches for the navy of Kaiser Wilhelm of Germany;

1. *A History of Men's Fashion,* Farid Chenoune, p. 212.

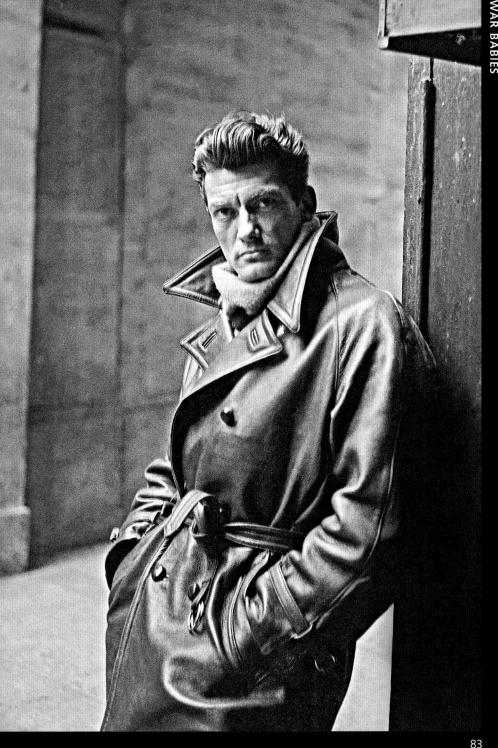

Previous page:
French actor
Jean Marais
leaning on a post
and wearing a
double-breasted
leather coat with
turned-up collar,
ca. 1946.

Top:
Perfecto from the
1930s.

Opposite:
Brando wearing
the definitive prole
gear: an army-
surplus G.I.
hooded parka,
as sold in Army
and Navy stores in
the 1950s and
1960s.

however, the idea was considered too eccentric. Although there were wrist-worn watches, such as the one made by Louis Cartier for his friend the aviator Santos-Dumont, it was not until the First World War that the convenience of the wristwatch was realised. Rather than fumbling inside their uniforms for a pocket watch, soldiers needed only to pull back the cuff to reveal the time on the wrist.

Since then, war has influenced much in watch design. The Cartier Tank is based on the first lumbering mechanised armour that appeared on battlefields between 1914 and 1918. The IWC Big Pilot, used during the Second World War, typifies the aviator's watch characterised by an oversized black dial with easy-to-read luminous numerals and a large winding crown enabling it to be operated with gloved hands. The popular and similarly-overscaled Panerai started as a watch for underwater commandoes of the Italian navy who rode on midget submarines to plant mines on enemy shipping.

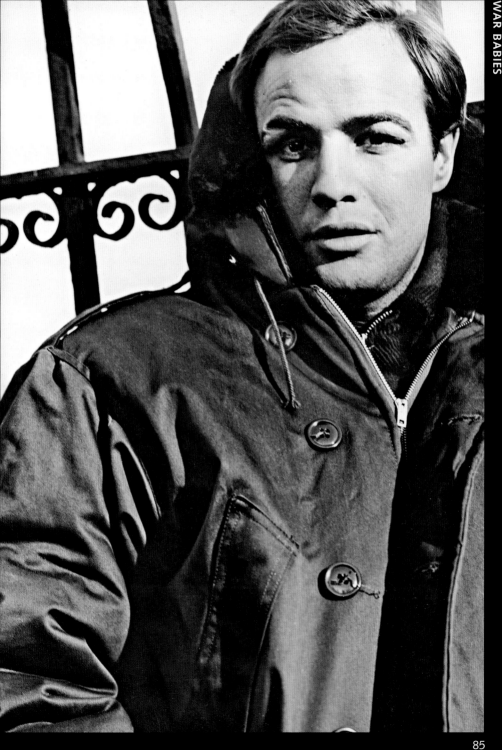

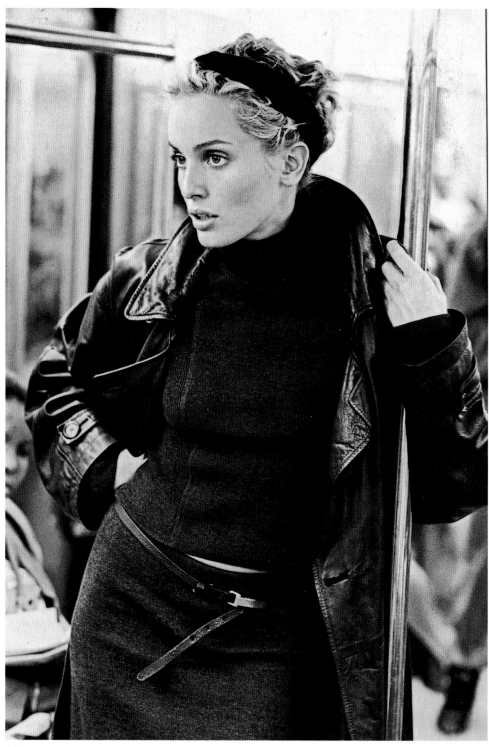

Beri Smither wears a Donna Karan black leather trench in the New York tube, Autumn 1994

Fashion

"Mr Burberry cared for little outside his business except temperance, religion, and agriculture, and he never read novels. He was a teetotaller and a nonsmoker. He had a house in Weybridge, and in that town he carried on a temperance campaign, mainly directed to Sunday closing. The illness which caused his death is believed to have originated through his preaching a sermon at a Salvation Army gathering about a fortnight ago."

So ran the obituary notice for Thomas Burberry in the *Daily News* of Wednesday, April 7, 1926, who "had died on Easter Sunday at his residence at Hook, near Basingstoke, in his 91st year."[1]

It is hardly surprising, then, that the promotional activity undertaken during his lifetime was given over to proselytising about the durability and health-giving properties of his gabardine clothing. For a man like Thomas Burberry, the trench was

1. *Daily News*, April 7, 1926, reproduced in *An Elementary History of a Great Tradition*, published by Burberry, August 1987.

A model wears a trench coat and hat supplied by the classic clothing retailer Burberry, ca. 1930

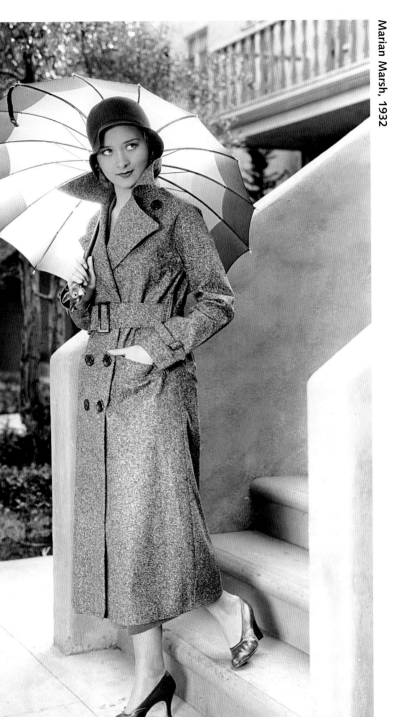

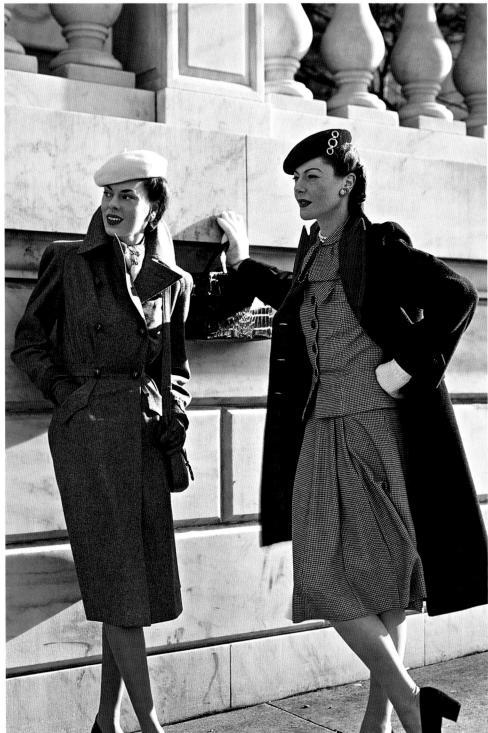

Two models, one wearing a grey flannel trench coat, the other a navy reefer coat of wool chinchilla and a checked wool suit, ca. 1943

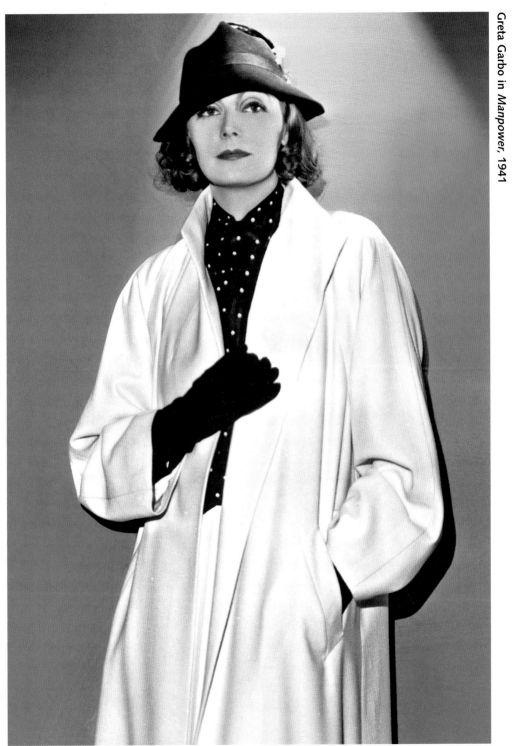

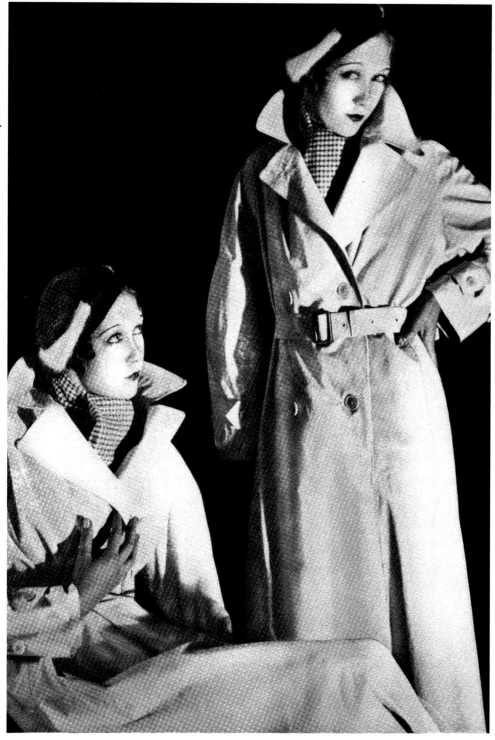

Tᴇʟ. No.: TROJAN 2000
Eₓₜₙ. **2065.**

Further correspondence on this subject should be addressed to:
The Under-Secretary of State (**Ord 17(b)** .)

THE WAR OFFICE,

CHESSINGTON,

SURBITON, Sᴜʀʀᴇʏ.

Please quote in any reply:

1502/281(Ord 17).

21 May, 1954.

Gentlemen,

Trench Coat.

 Reference your inquiry of 4th. May, 1954, in connect
ion with the above, the particulars requested are
enclosed herewith.

 I am,
 Gentlemen,
 Your obedient Servant,

 [signature] M. Arnold Main

 Director of Ordnance Services.

Messrs Aquascutum Ltd.,
100, Regent Street,
London, W.1.

a serious affair. The role that fashion plays in the construction of today's trench would, most likely, be interpreted by Burberry and his contemporaries as an almost immoral frivolity—if they were alive to bear witness to it. And one can only imagine what they'd think of some of the deliberately risqué garments based upon aspects of the architecture of the original trench...

Given the increasing influence of that sine qua non of the twenty-first century fashion house, the "creative director," there is perhaps a tendency to see the high-fashion status accorded the trench as a modern phenomenon. Not a bit of it. The fashion credentials of rainwear reach back to the nineteenth century.

Take for instance the trend towards the end of the twentieth century for so-called "signature" checks from the likes of Aquascutum and Burberry. More than a century before, during the 1880s and 1890s, checked rainwear was very much in vogue for men and women. Moreover, there seems to have been a convention that

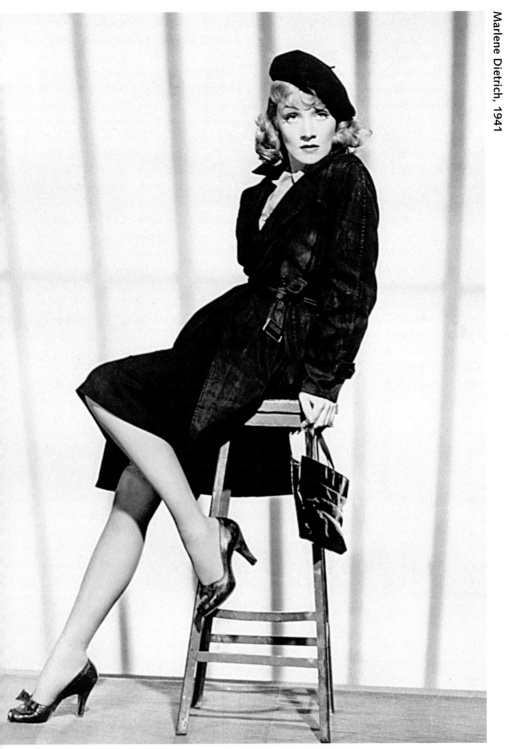

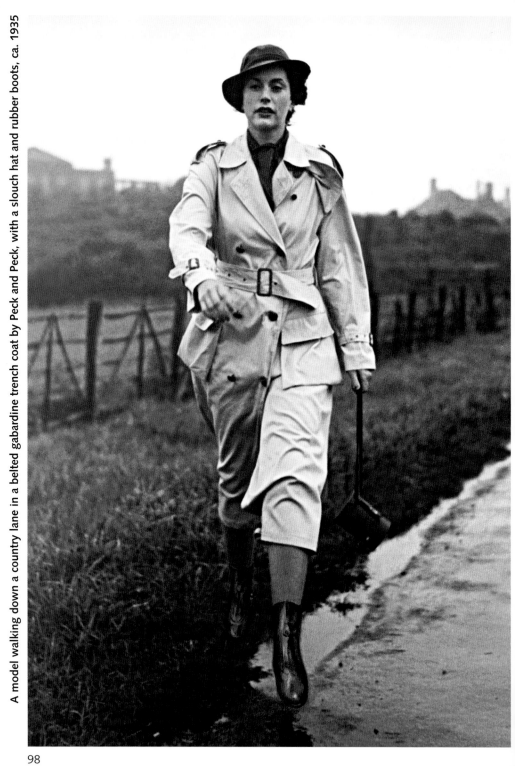

A model walking down a country lane in a belted gabardine trench coat by Peck and Peck, with a slouch hat and rubber boots, ca. 1935

A female detective shines a light at a burglar

The 81-year-old Claudette Colbert onstage in *Aren't We All?*, 1985

rainwear, irrespective of brand, carried a checked lining. During the nineteenth century, perhaps in deference to the Scottish ancestry of its eponymous founder Charles Macintosh, tartan linings were popularised and indeed registered,[2] by Macintosh & Co., and today the coats of Aquascutum, Burberry, and Barbour—the last itself a trench coat maker in the past with a model called the Safeguard Belter[3]—are all distinguished by a readily identifiable checked lining.

However, in the middle years of the twentieth century, while the trench coat enjoyed huge popularity, it was on the whole a conservative garment in sober military shades of khaki, olive, blue and grey.

There are two reasons for the ubiquity of the trench coat between the wars. First, the government found itself with a surplus of military equipment and clothing, so during the 1920s many aspects of trench dress found their way into civilian wardrobes. Moreover, as the *Handbook of English Costume in the Twentieth Century,*

2. Manchester Mackintoshes, p. 60.
3. Barbour Trade Catalogue of 1939.

The fashion credentials of rainwear reach back to the 19th century.

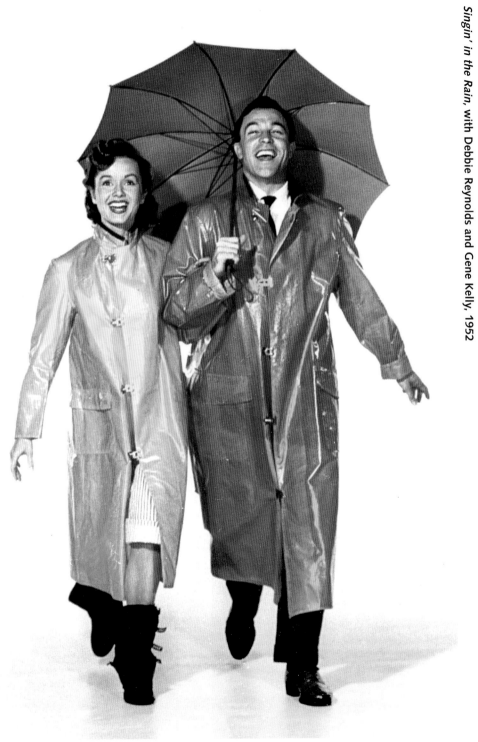

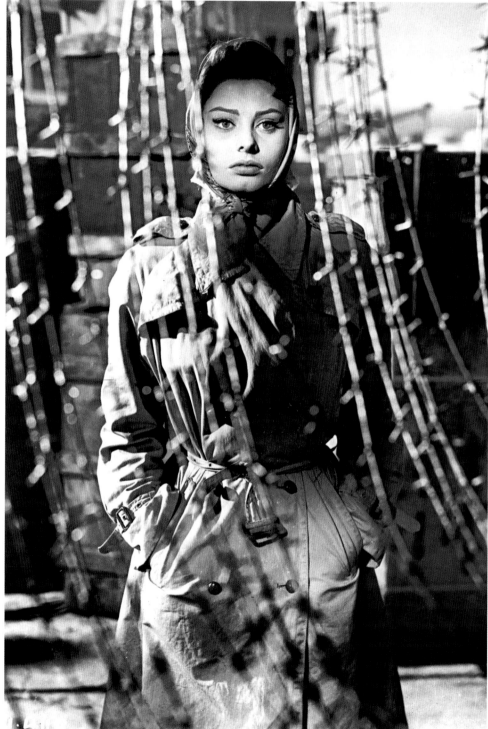

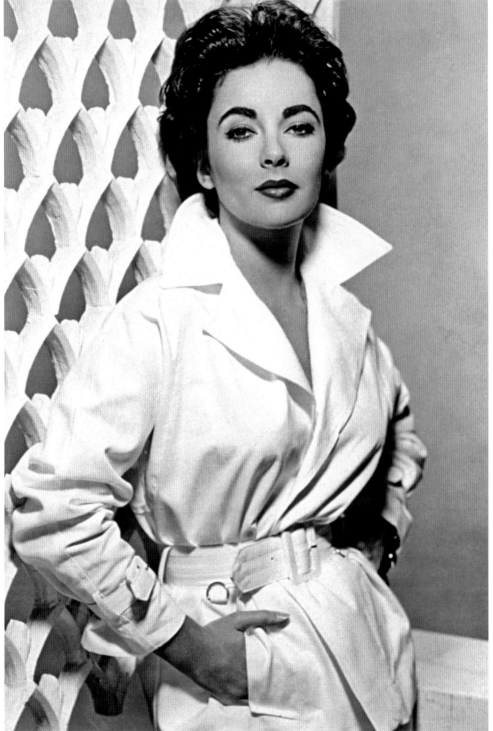

The trench style shows a return in force in collections. Not necessarily in its traditional shape, but numerous brands have revisited it, each in its own way.

Lionel Guérin, manager of the French menswear industries

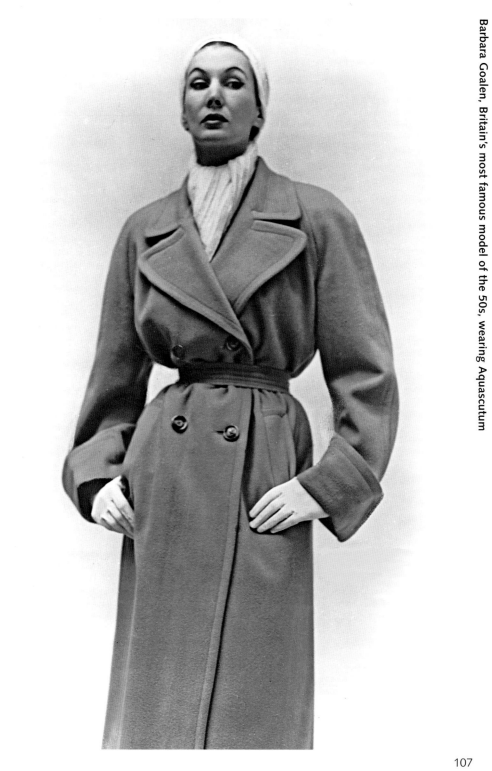

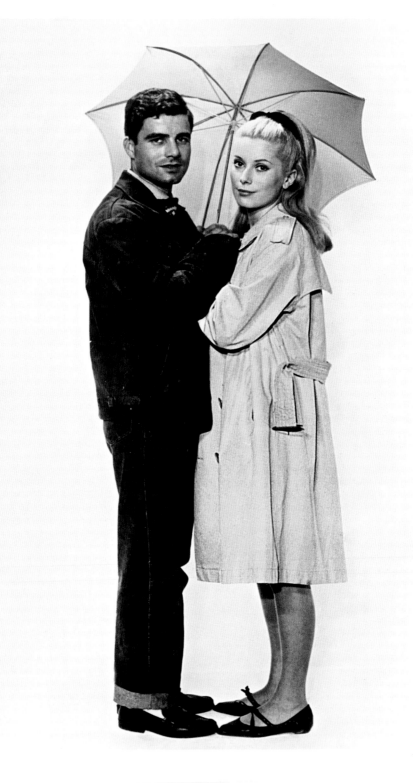

The Umbrellas of Cherbourg with Nino Castelnuovo and Catherine Deneuve, 1964

Julie Christie wears a trench coat in a still from the film *Petulia*, 1968

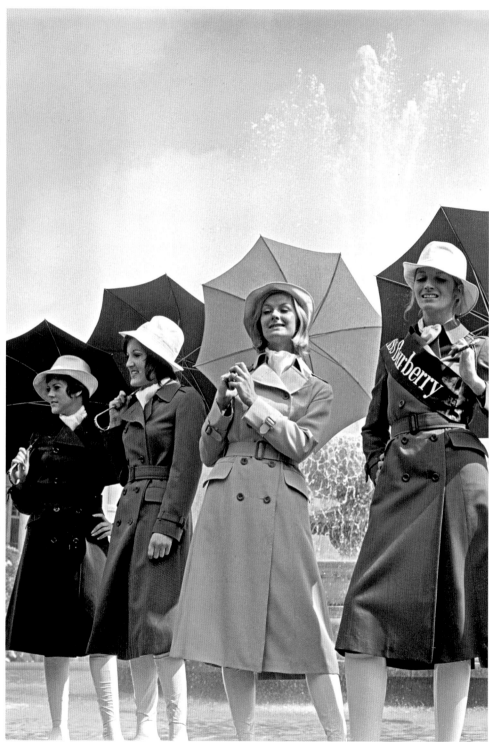

Brenda Capwell, "Miss Burberry," poses in London's Trafalgar Square with three other models in Burberry fashions, May 27, 1970

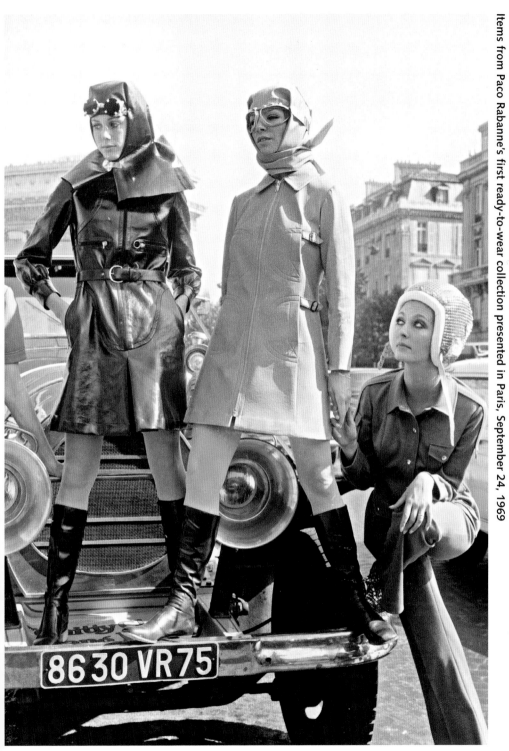

8630 VR75

Anna Karina in *Made in U.S.A.*, 1967

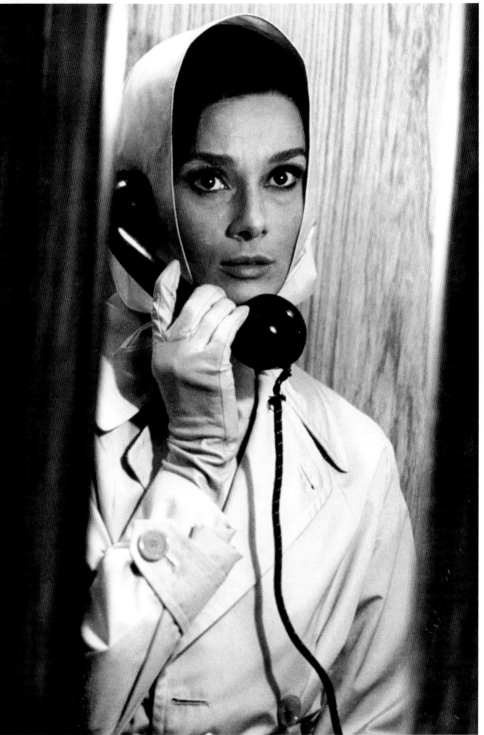

Honor Blackman in Aquascutum while performing on stage in *Mr. & Mrs.*, 1968

The trench coat segues elegantly from war to peace.

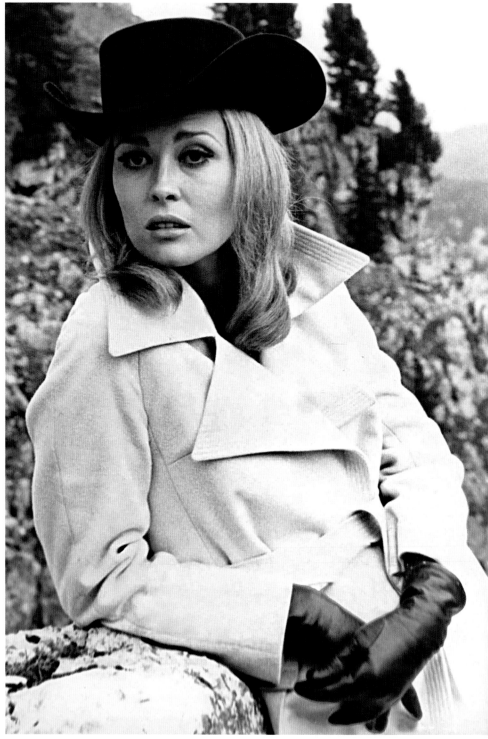

Faye Dunaway in *A Place for Lovers*, 1969

1900–1950 explains, "At the end of the war it was inevitable that many ex-officers were glad to make use of their uniform trench coats and 'British Warms' on return to civilian life…"[4]

These trench coats proved almost indestructible. Customers used their coats for decades and fully expected their coats to outlive them, intending to pass them on to future generations. Others had used theirs to patch up broken windows or as impromptu washbasins and reported that they were as weatherproof and waterproof as ever.

Thus the trench coat segued elegantly from war into peace. A survey of clothing catalogues of the late 1930s, as the world stood on the brink of another war, reveals that many aspects of the architecture of the trench had been adopted for civilian use: The "Famous Aquascutum Storm Coats" advertised at this time were made to a design that had changed little in almost a quarter of a century. In particular, the model number G.9[5] was unaltered in every respect.

4. *Handbook of English Costume in the Twentieth Century, 1900–1950,* Alan Mansfield and Phillis Cunnington, Faber and Faber, 1975.
5. Exactly the same coat appears in another catalogue with a slightly different caption and the model number G.83.

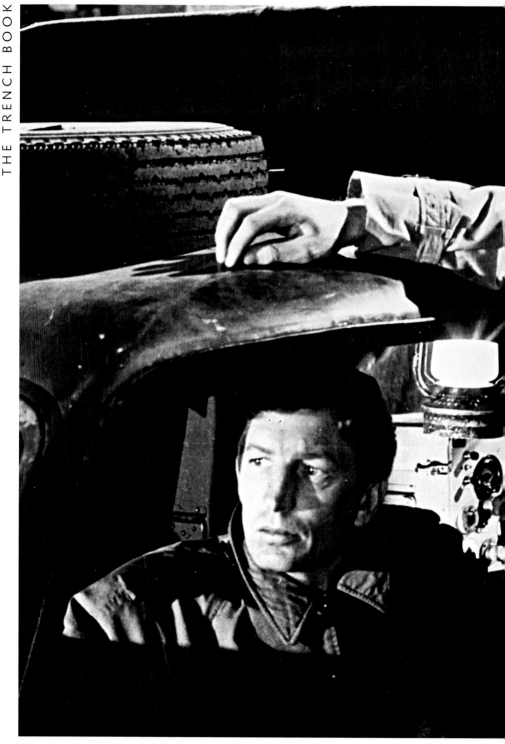

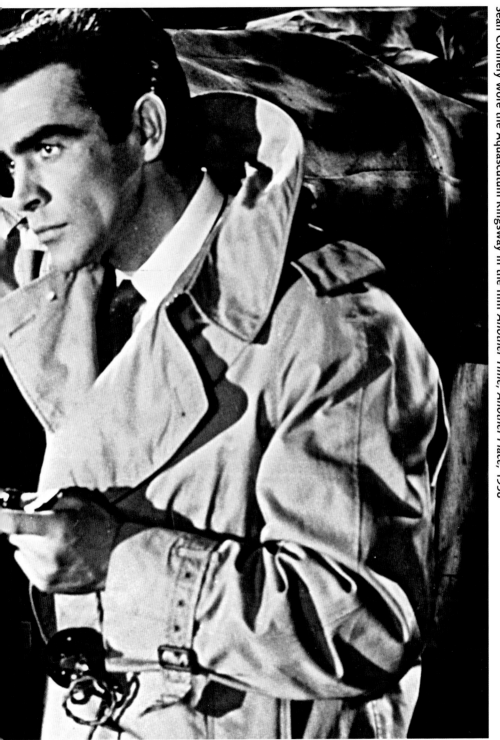

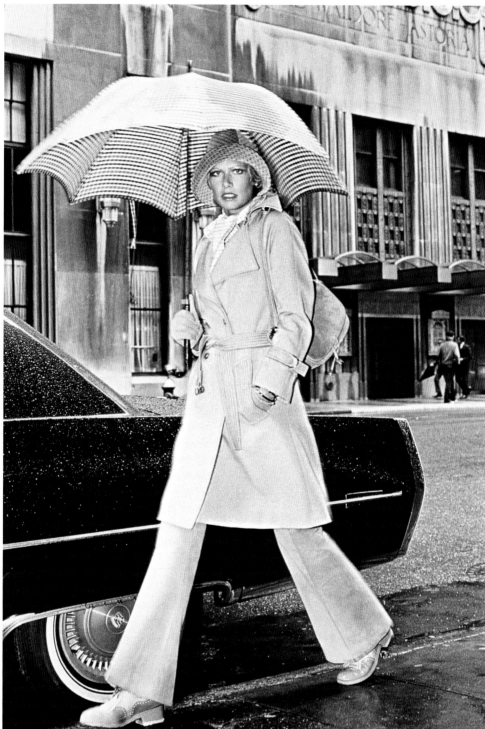

A model wearing a wool gaberdine trench coat by Christian Aujard over a shirt by Ralph Lauren and pants by Leslie Fulop, ca. 1972

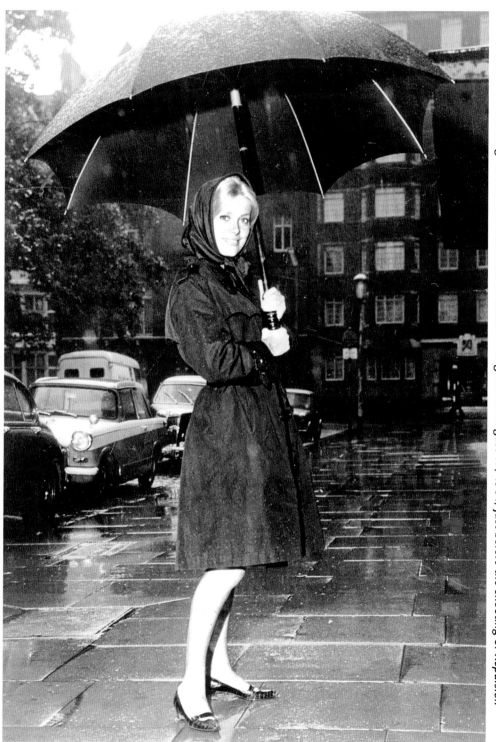

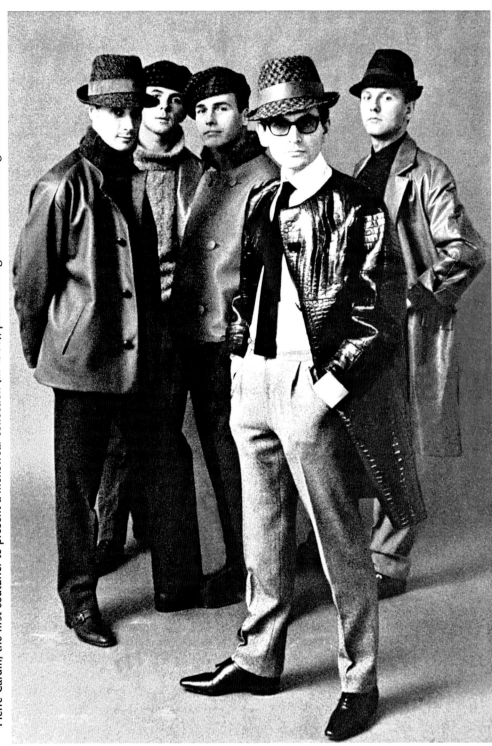

Pierre Cardin, the first couturier to present a menswear collection (in 1960), poses among his models wearing a crocodile-skin coat, 1969

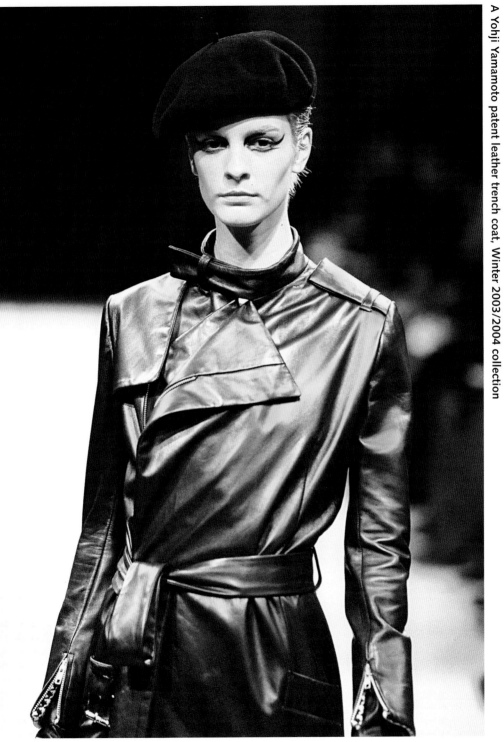

A Yohji Yamamoto patent leather trench coat, Winter 2003/2004 collection

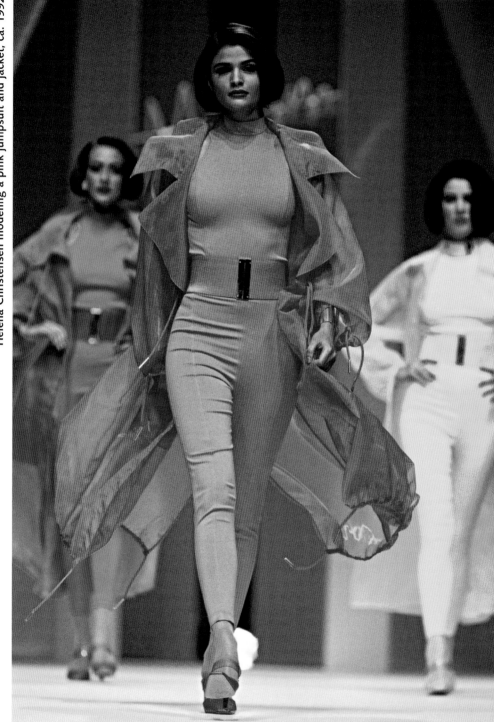

Beige, black or pretty in pink.

"This was originally designed for the rigorous conditions created by trench warfare, and is one of the most successful weatherproof coats designed. It is, however, equally suitable for either civil or military conditions, and features include raglan sleeves, deep storm collar, large throat tab, strap cuffs, large D.B. lapels, a yoke back, and inside straps for riding. The shoulder straps are detachable."[6]

In 1936, Dexter Weatherproofs offered trench-inspired models under the names Elderslie (apparently recommended for the man under 30). The Lockerbie was billed as "the kind of coat that makes you forget the weather and concentrate on the game," while Dexter's Eskdale was both "smart for country wear, and a favourite with business men."[7] Barbour's Safeguard Belter of 1939 came with a storm flap, a throat strap, a wrist strap and, of course, a belt. The Army and Navy Catalogue of the same years offered what it called the chauffeur's coat. This

6. Advertising brochure for Aquascutum coats, late 1930s.
7. Dexter Weatherproofs catalogue, 1935.
8. Army and Navy catalogue, 1939.

Transparent J.C. de Castelbajac raincoat, with postcards of Paris in its pockets, from the spring-summer 1992 collection

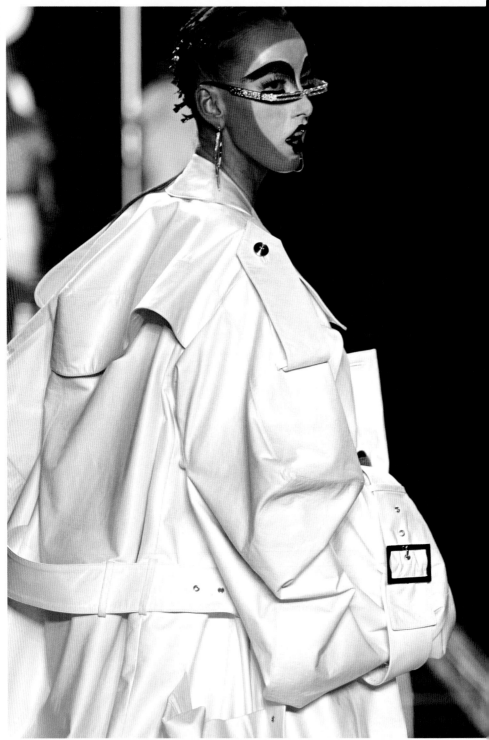

raglan-sleeved, double-breasted coat was described as "very durable and absolutely water-proof"[8] and would have been familiar to anyone who had served in the trenches. The Army and Navy Stores also offered Zambrene youths' and boys' raincoats in a "Double-breasted Trench Coat Style."[9] Prices for children started at 35 shillings for a size three and rose by one shilling and sixpence per size thereafter.

Ironically, the Second World War would see the decline of the trench coat's military use. The increasingly mechanised and highly mobile form of fighting during the 1939–1945 conflict was totally different from the static trench warfare of the First World War. Although trench and storm coats were worn, shorter combat jackets allowing greater mobility became ubiquitous amongst fighting men. Although one of the legacies of this era is the grim image of the evil Gestapo officer in his leather trench coat; in this instance one can say that it was adopted more for sinister effect than for battlefield practicality.

9. Army and Navy catalogue.

I'm definitely shy, so it was acting for me to drop a trench coat and be in a bikini and try to get my cousins out of trouble by using my body.

Jessica Simpson

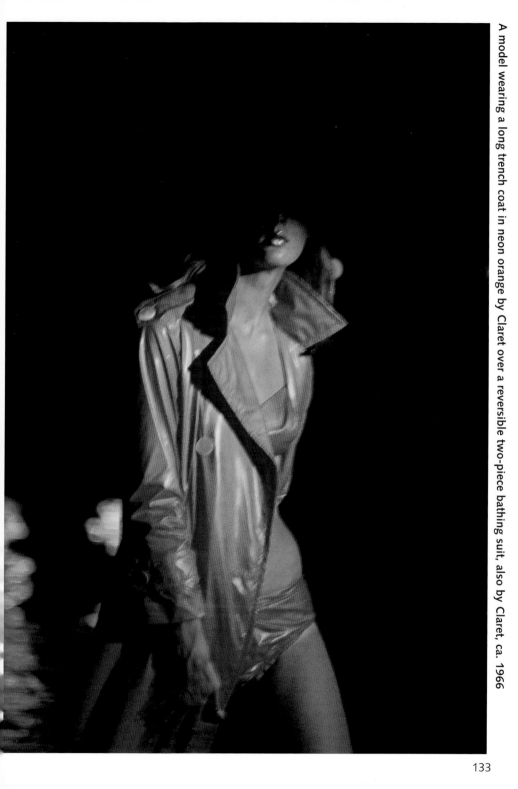

A model wearing a long trench coat in neon orange by Claret over a reversible two-piece bathing suit, also by Claret, ca. 1966

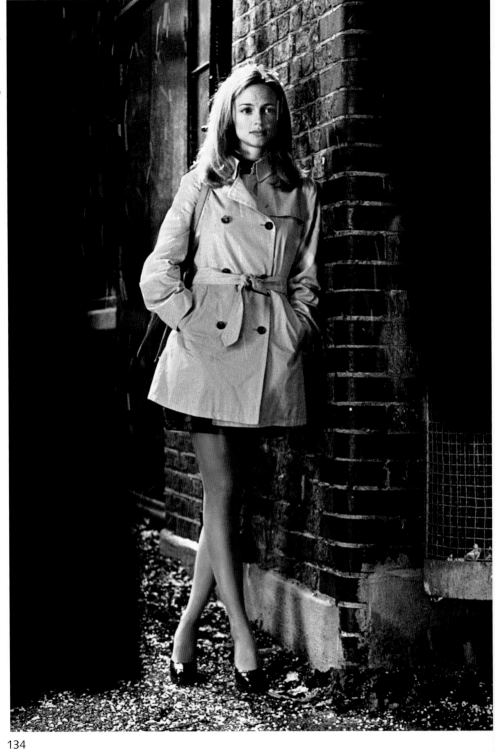

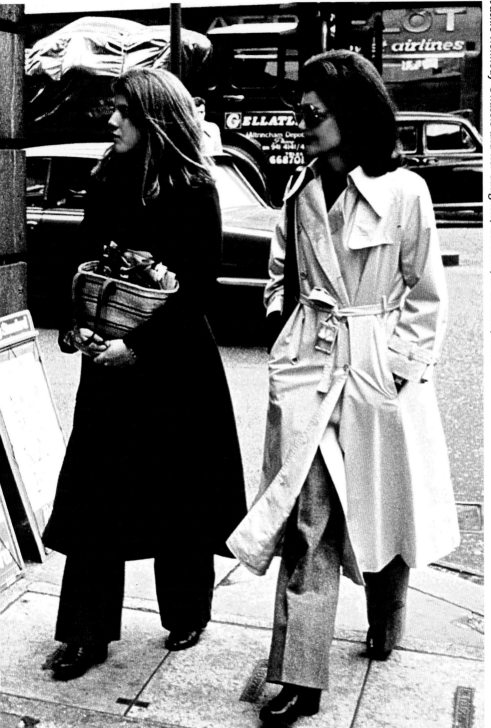

Jackie Kennedy Onassis and her daughter, Caroline, in London, 1979

The trench coat is a civilian classic.

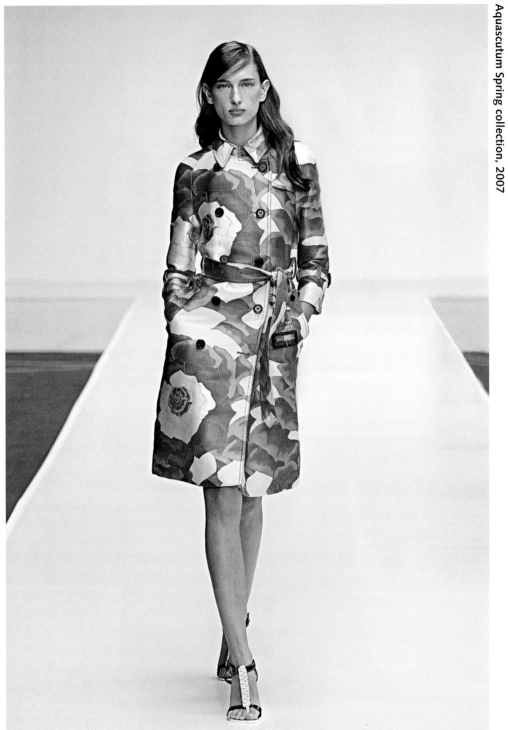

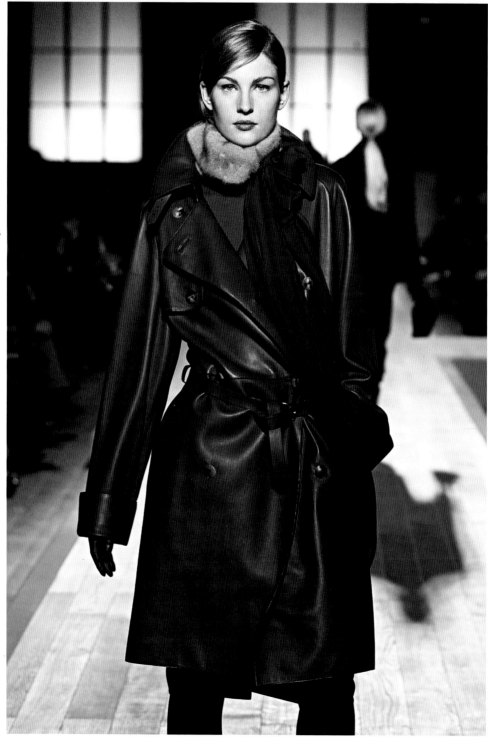

From the Hermès ready-to-wear collection, Fall-Winter 2006/2007

As military dress evolved, the trench coat remained a civilian classic, incorporating the new technical and man-made fabrics that appeared during this time. When Sir Edmund Hillary and Sherpa Tensing Norgay reached the summit of Mount Everest in 1953, they were protected against the extreme climate by Wyncol D711, a high-tech cotton and nylon mix, which was subjected to wind tunnel testing by the ministry of supply and found to be able to resist winds of up to 100 mph. Wyncol D711 was subsequently used in Aquascutum's "Expedition Coats," which were described as "the most talked-about and sought-after raincoats in the world."[10]

Indeed, the years after the Second World War saw Aquascutum embrace new technologies and innovative materials, long before technical and performance fabrics became fashionable. Aqua Five, hailed as "the greatest technical advance in rainwear," was another high-tech initiative by a firm that by this time was well over a century old and yet right at the forefront of new

10. Advertisement for the Expedition Coat, placed in *The New Yorker*.

From the Gaultier ready-to-wear collection, Fall-Winter 2006/2007

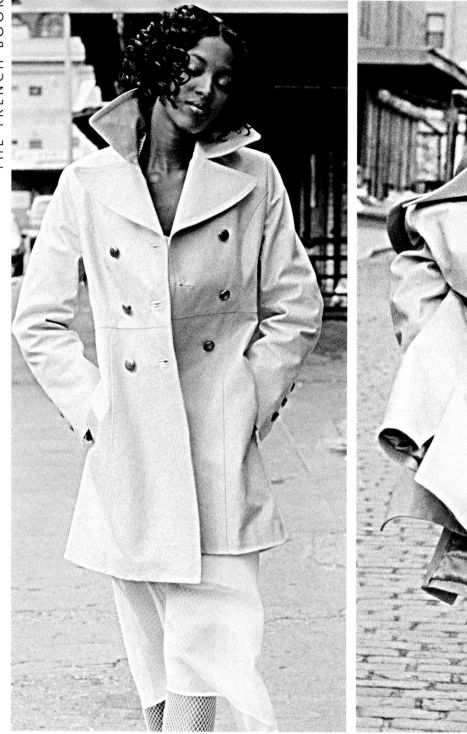

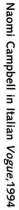

144

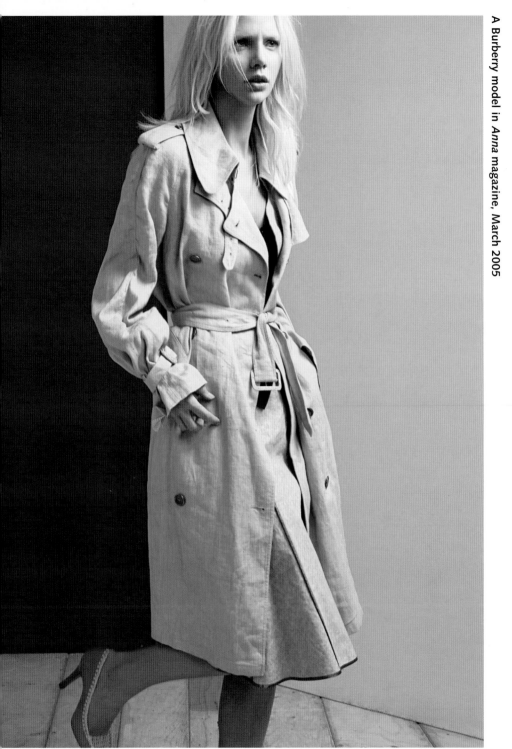

developments. Aqua Five was a process whereby each fibre of the fabric was impregnated with a treatment that accomplished five specific objectives, which were:

1. The highest standard of water repellency ever achieved

2. Easy removal of oil and grease marks

3. Improved crease resistance

4. The end of reproofing after dry-cleaning

5. Water repellency for the life of the garment[11]

This was seismic stuff for the trench coat, and Aquascutum knew it. The Aqua Five launch on September 9,1959 was a world media event. A typed sheet, which has lain in the archives of Aquascutum for almost 50 years, shows the sort of guests that Aquascutum expected to attend. As well as representatives of the major newspapers, invitations had been sent to Hardy Amies, Margot Fonteyn, Frederick Ashton, Richard Attenborough, war hero air ace Douglas Bader, Cecil Beaton, Douglas Fairbanks, Lew Grade, Jack Hawkins, Kenneth More, Stirling Moss, Oliver

11. Technical specifications for Aqua Five from the 1959 pre-launch sales leaflet, p.1.

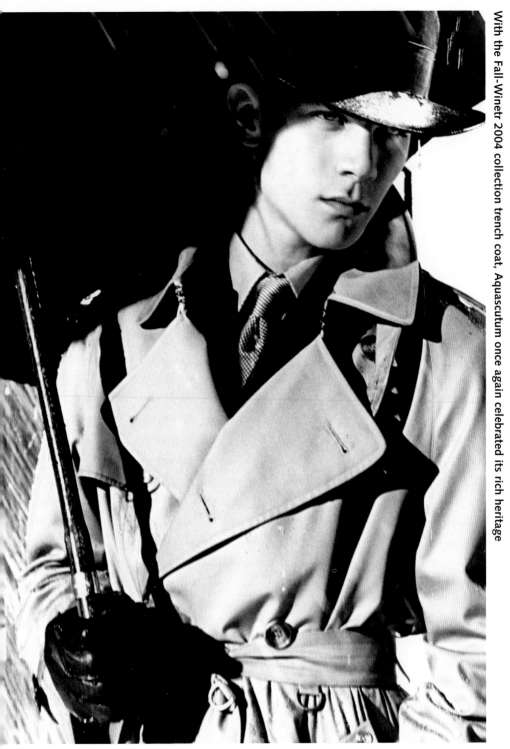

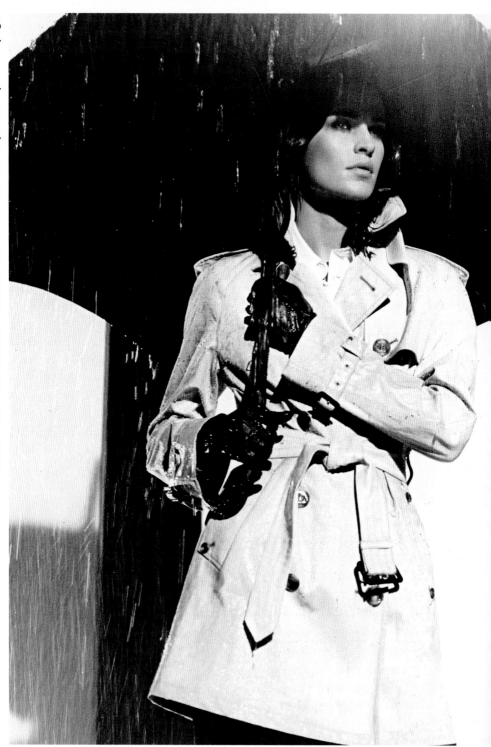

The Fall-Winter collection 2004 womenswear trench coat counterpart (see previous page)

Messel, Sir Laurence and Lady Olivier, Mr. and Mrs. John Profumo, Sir William Rootes and Sir Malcolm Sargent.

Aqua Five had been developed with the Cotton Board. Its chairman, Lord Rochdale, delivered an address at the luncheon held to mark the event, trumpeting what he proudly called "another example of Britain's leadership in rainwear."[12] And then, with a theatrical flourish, 48-year-old Elsie Newman, who had worked at Aquascutum's Kettering factory for 26 years, doused a pair of models wearing the coats in Champagne; the next day Mrs. Newman flew to America to present one of these miraculous new coats to Mrs. Eisenhower, the wife of the president. The resulting publicity storm was remarkable, and Aquascutum's Aqua Five made its contribution to political life with a stain-proof macintosh appearing in a Vicky cartoon concerning the travails of Prime Minister Harold Macmillan.

With such major technological advances as Wyncol and Aqua Five improving the performance of the trench coat, it was not long before it

12. Quoted in an unidentified press clipping, Aquascutum archives.

attracted the fashion-forward designers of the era. It was during the late 1960s and 1970s—ironically, a time when social order and the accepted value system were under threat—that the trench coat, once the favoured outer garment of the Establishment, got a full fashion makeover. In the era of peace and love, military clothing got an ironic treatment. Among the styles popular on Carnaby Street and Kings Road were the red jackets that had been worn by the British Army at the end of the preceding century. There was even a shop called "I Was Lord Kitchener's Valet." Nothing was sacred...not even the trench. Early signs of what fashion would do to the trench could be seen in 1965. Young fashion student Raymond Clark designed an evening coat and dress modelled from the trench coat and executed in lace and diamanté—with notional weatherproofing provided by the newfangled Scotchguard treatment. The designer became hugely influential and famous under the name Ossie Clark.

By the end of the decade it was open season for

the trench. Balmain was experimenting with a trench in tweed and beaver skin. Daniel Hechter made a zip-front trench coat for toddlers, which used "ecru silver knit jersey with a furry lining" and came with matching flared trousers. Not to be outdone, Karl Lagerfeld, working for Chloe, designed a "sunflower yellow pure worsted wool gabardine" summer trench coat with wide, almost tentlike sleeves. An Ungaro trench of 1971 went sexy with exaggerated detailing and topstitching, accessorised with a large cowboy hat, riding boots, and little else, photographed by Helmut Newton. By the seventies, there were quilted trenches, python-skin trenches, denim trenches, leather trenches, plastic trenches, Terylene trench-es, velour trenches…

Even Aquascutum, the high temple of the trench, was going groovy. A generation earlier, it had been exhorting men to buy military storm coats worn for king and country with a stiff upper lip. In 1972, it proposed the flamboyant Aquascutum Highwayman—a garment that was part trench,

War is hell, but in fashion terms it can be a bonanza.

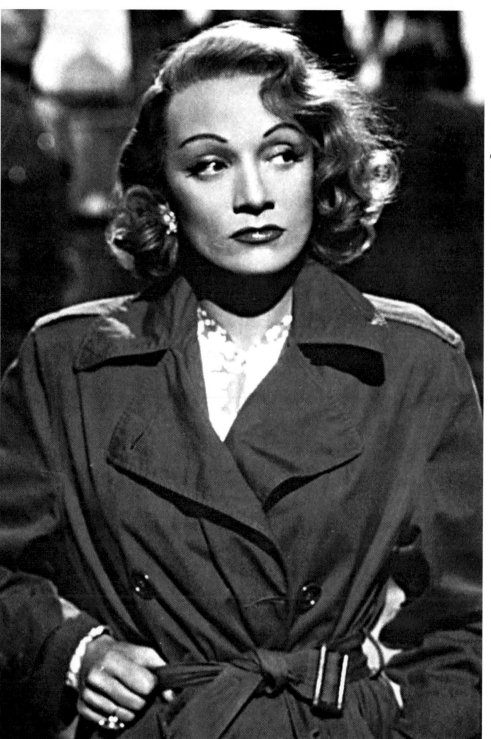

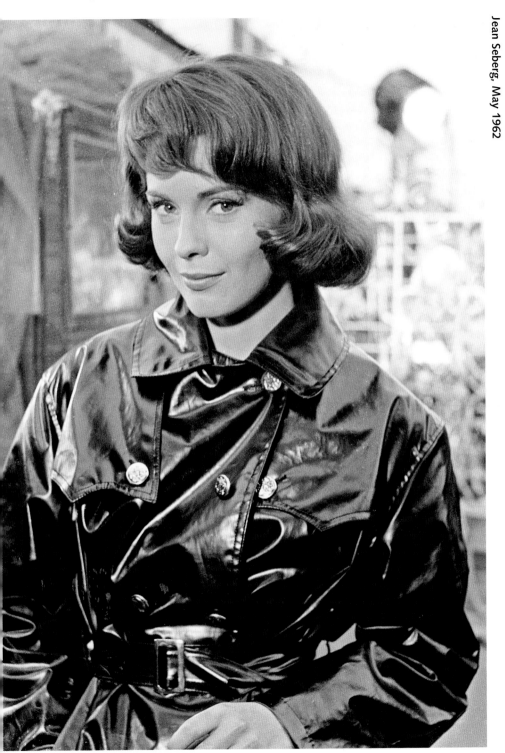

part greatcoat, and all Austin Powers. Yeah, baby. Things calmed down again in the 1980s when, doubtless as a reaction against the style excesses of the sixties and seventies, the pure trench was rediscovered. The Eighties was a time of the soi-disant design classic, and the trench was duly celebrated as such in Paul Keers's 1987 dressing manual, "A Gentleman's Wardrobe: Classic Clothes and the Modern Man," and a 1989 exhibition at the Victoria and Albert Museum.

By the end of the century, the metronome of fashion was swinging in the other direction. The middle of the first decade of the twenty-first century saw floral trenches and even charity trenches, namely Burberry's pink trench helped raise money to combat breast cancer. Designers vied to outdo each other with ever more exotic and expensive trench coats, and just as they had during the seventies, the major houses responded with flamboyant garments such as Aquascutum's Jackson Pollock-esque paint-spattered trench (a worthy successor to the Highwayman!).

Designers vied to outdo each other with ever more exotic and expensive trench coats.

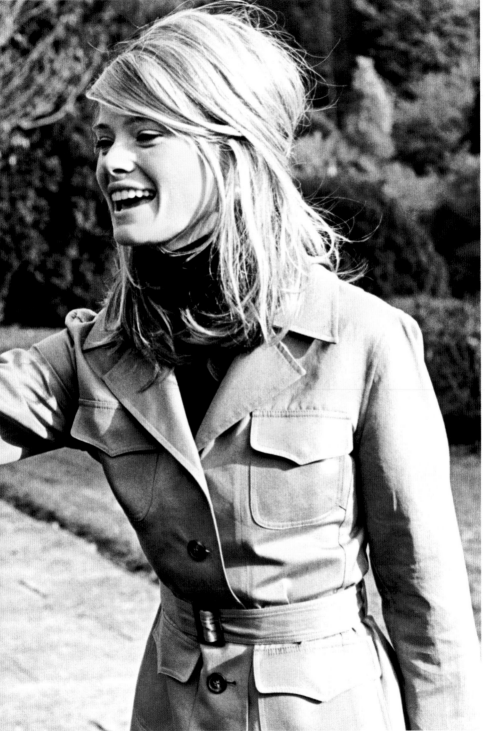

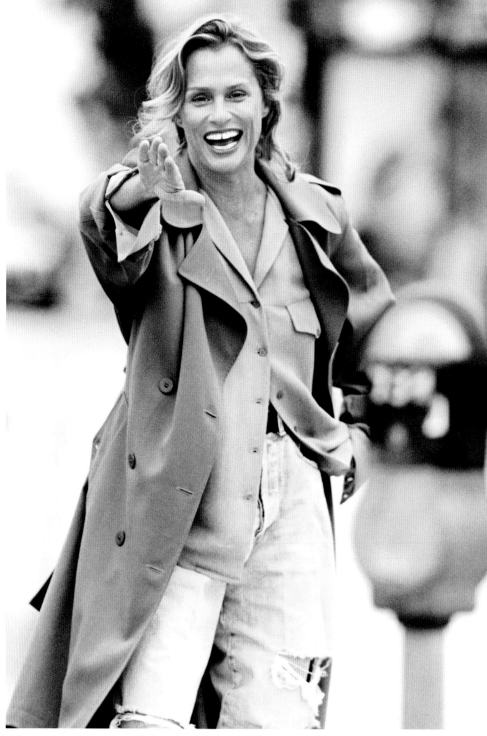

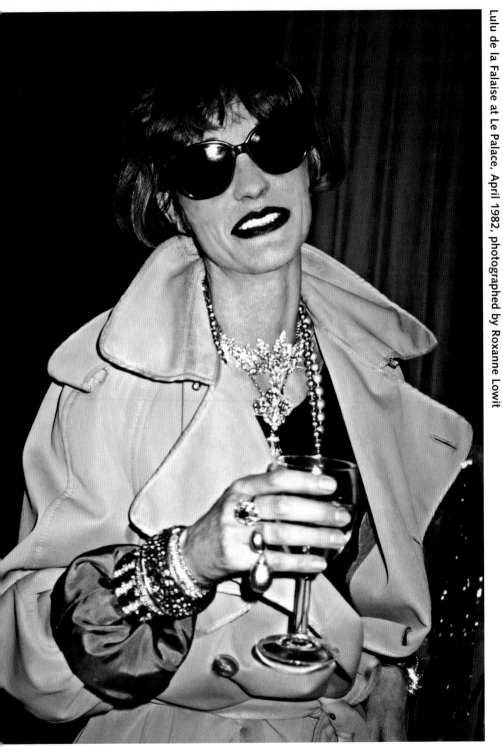

Lulu de la Falaise at Le Palace, April 1982, photographed by Roxanne Lowit

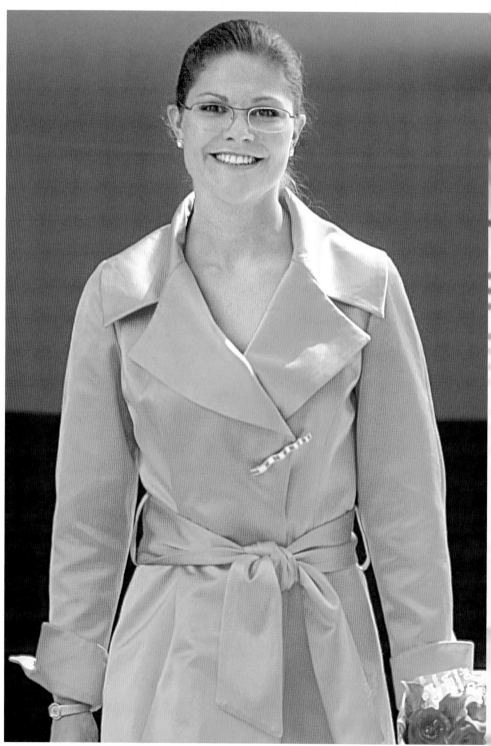

Sweden's Crown Princess Victoria at the Swedish Embassy in Tokyo to inaugurate the exhibit "Home Swedish Home," April 7, 2005

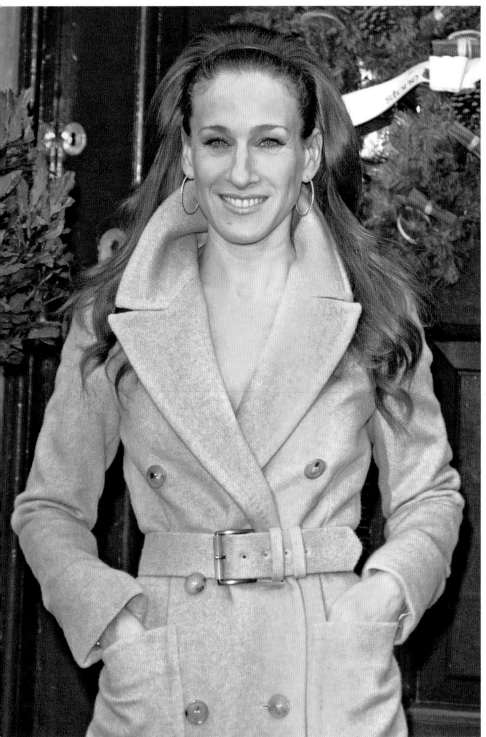

Sarah Jessica Parker during a photo shoot in London to promote her movie *The Family Stone*, 2005

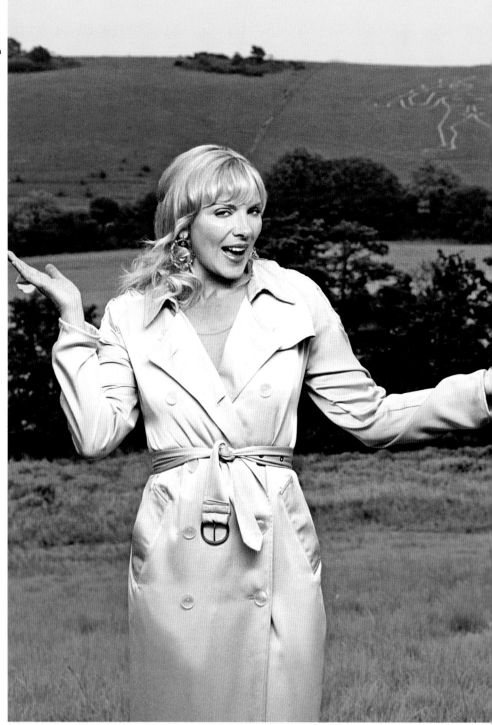

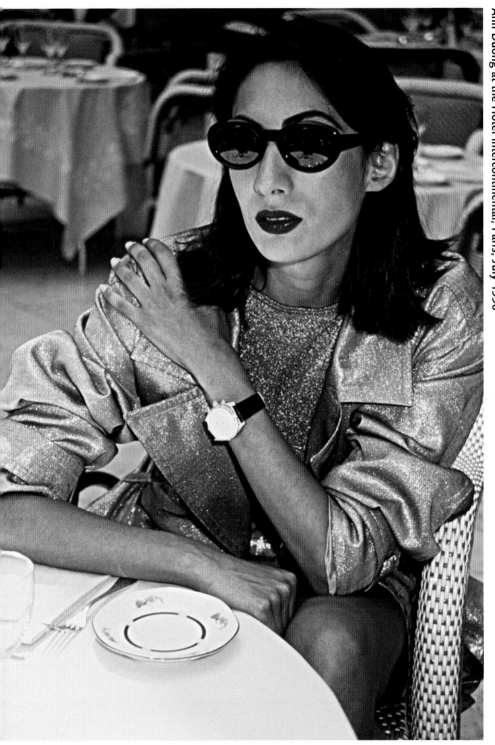

Ann Duong at the Hotel Intercontinental, Paris, July 1990

The trench coat is locked into the DNA of some of the world's best known brands.

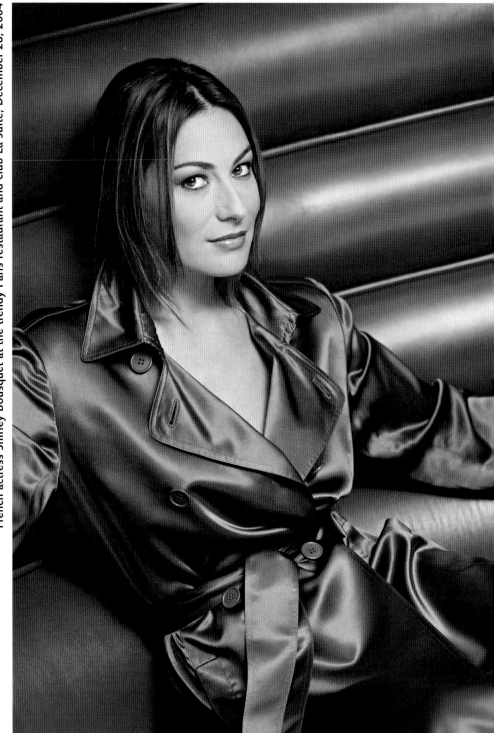

French actress Shirley Bousquet at the trendy Paris restaurant and club La Suite, December 28, 2004

American actress Sharon Stone promotes her film *Basic Instinct 2* at the Four Seasons in London, 2006

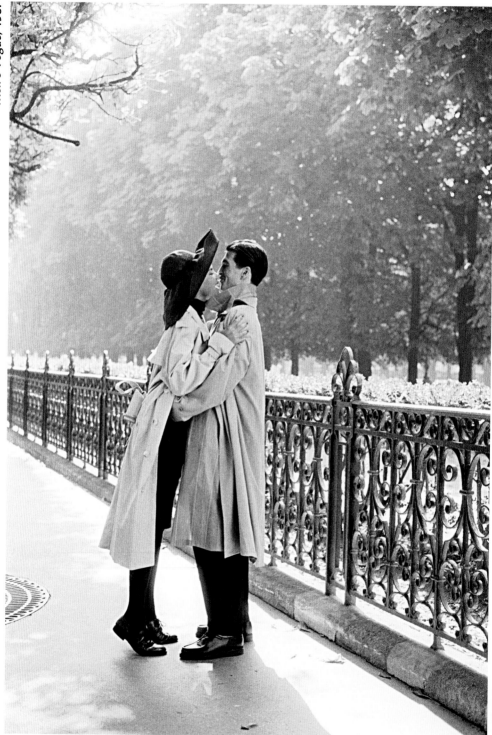

The trench coat illustrates the tendency of the current men's fashion: to adapt basic clothes to other materials and to new forms.

François Dubus,
director of Printemps Department
Store, Paris

MYTHOLOGY

Graeme Fidler

Graeme Fidler is the head of menswear design at Aquascutum and a young designer who has done much to rehabilitate the trench coat among the fashion literate. He is known for his capacity to reinvent the trench without resorting to gimmickry.

Nick Foulkes: How important is the trench coat to your understanding of Aquascutum?

Graeme Fidler: "It is a necessity not just for me but for the brand and the heritage. If you reflect on the brand's history and heritage, it is a form of our 'handwriting.'"

N.F.: How often do you draw upon the trench for inspiration in your work?

G.F.: "On a seasonal basis, there is always an element of the trench, always. Creatively, it's an exciting challenge to refer to something perceived as a classic, and look at ways of revising that piece for today and beyond. It is truly one of those iconic items that most people have, or aspire to have, in their wardrobe. However you use them, there are so many elements of the classic trench that it never becomes dull. You can always find something new among the details of a trench coat. It is this aspect of discovery in working with the trench that makes it so exciting for me as a designer."

N.F.: Do you have a favourite feature to which you return?

Opposite:
Aqua 5 coat from Aquascutum's Fall-Winter campaign 2007 exclusive, luxury capsule collection inspired by stars of the Silver Screen Era.

Following pages: Fashion shot from Aquascutum's Fall-Winter campaign, 2006.

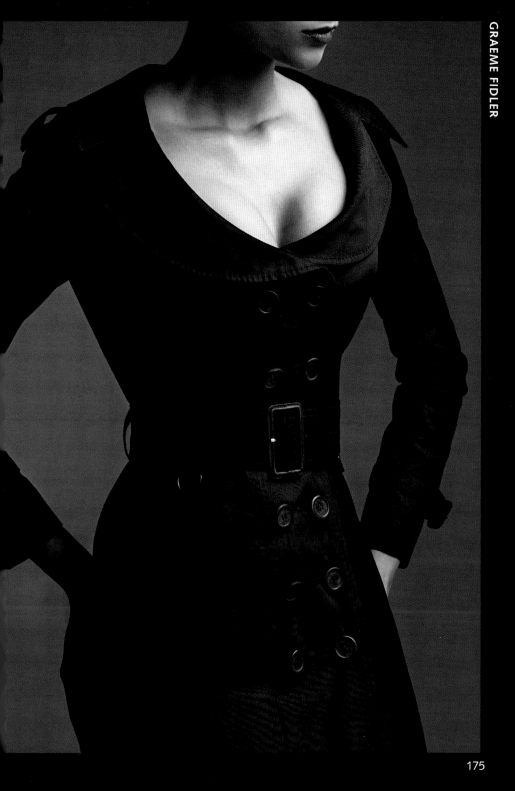

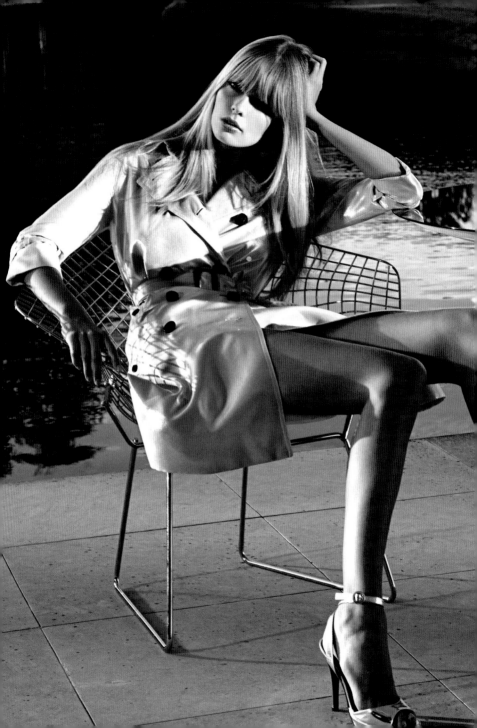

G.F.: "On numerous occasions I have used the throat tab concept, the cuff straps, and the storm guard."

N.F.: What is your definition of the hallmark of a trench?

G.F.: "The Vandyke stitching on the undercollar and the multiple stitching on the stand are details that are synonymous with the trench."

N.F.: Do you use archive pieces at Aquascutum when designing a new collection?

G.F.: "Of course, and not just archive pieces that are in the main collection. Since coming to Aquascutum, I have bought dozens of old trench coats, always for a specific detail; as a design maniac, its been a complete joy looking at the trench from this point of view. The cut of a sleeve, a special stitch...it may be just one thing on a particular garment that triggers a whole different line of thought."

N.F.: How do you keep the trench fresh on a seasonal basis?

G.F.: "A simple absolute trench coat can go from classic to fashion immediately if you reproportion it by cropping, elongating, reducing the volume, or, as in the case of a best seller, the Fairmont, making it single-breasted with set-in sleeves, but still using the epaulette and cuff strap. All it lacks is the double-breasted cut and the raglan sleeve, but a couple of changes like that can give it a sudden broad appeal. It is hugely beneficial to know and respect the ins and outs and foundations and fundamentals, as you can then spend more time on the finer details."

Opposite:
For Fall-Winter collection 2007 Aquascutum created modern coats using original designs worn by Hollywood divas in the 1950s.

Following pages:
Aquascutum's Club Check has always had iconic qualities. Originallly used for lining purposes, its various designs have been applied to Aquascutum garments and accessories for more than three decades.

p. 182-183
The trench
—epitome
of female
elegance—in the
Aquascutum AW

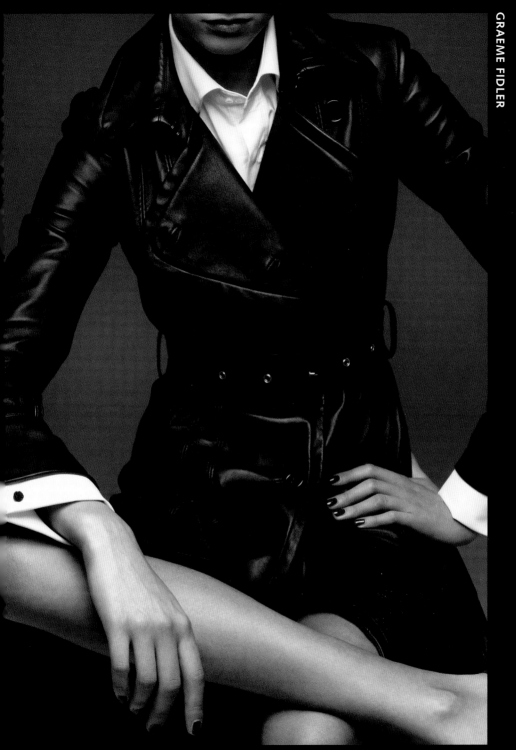

Aquascutum has
a reputation for
classic tailoring and
quality outerwear, and
its famous Club Check
is internationally
recognised.

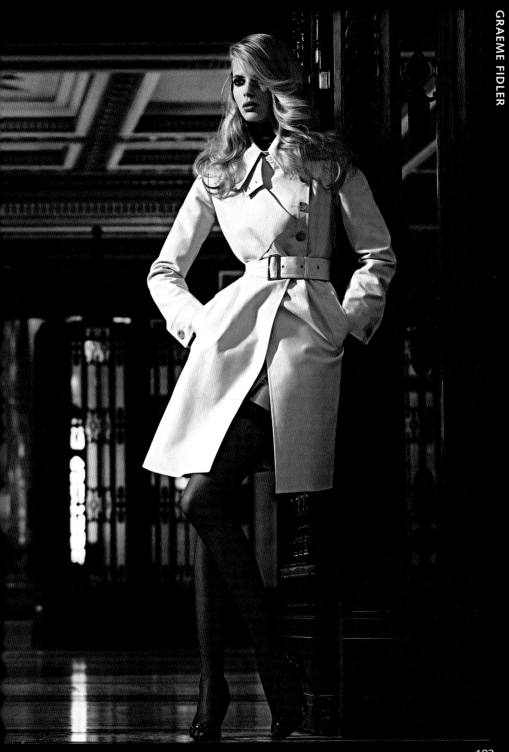

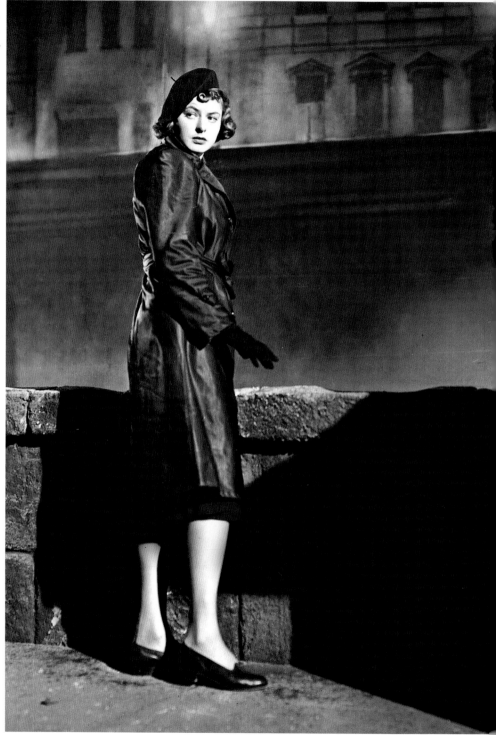

Ingrid Bergman in *Arch of Triumph*, 1948

Film

From Robert Mitchum to *The Matrix* and beyond, the trench's role in cinema is undeniable. Some of the most dramatic and romantic moments in film are inextricably bound with one— and moreover, the trench is a signature of some of film's foremost style icons.

Aquascutum has a long and illustrious history of working closely with film productions and the brightest of movie stars, those whose first name alone indicates icon status, Sophia, Lauren and Cary who all donned an Aquascutum trench during their careers. To

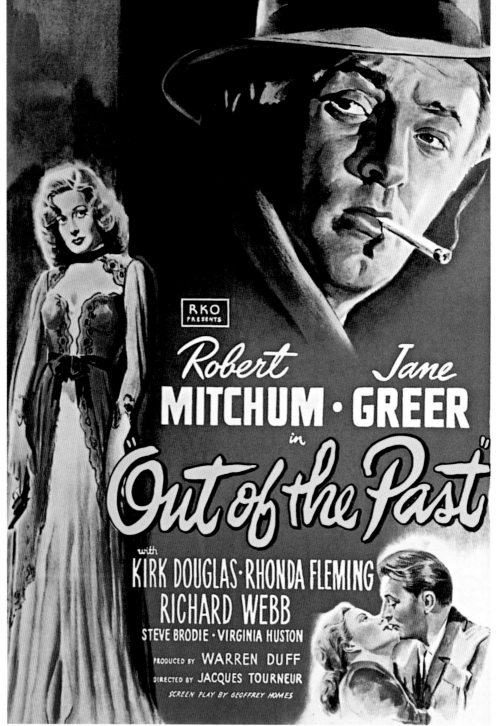

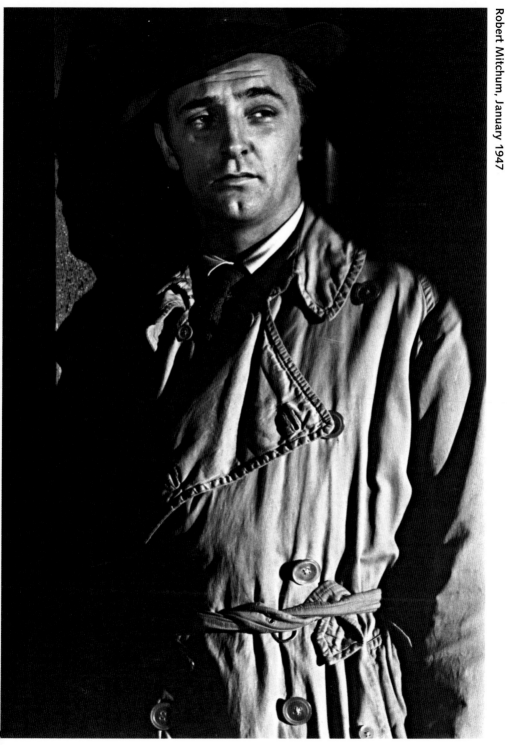

A page in the Aquascutum Visitors Book, recording amongst others, Lauren Bacall's visit, January 1959

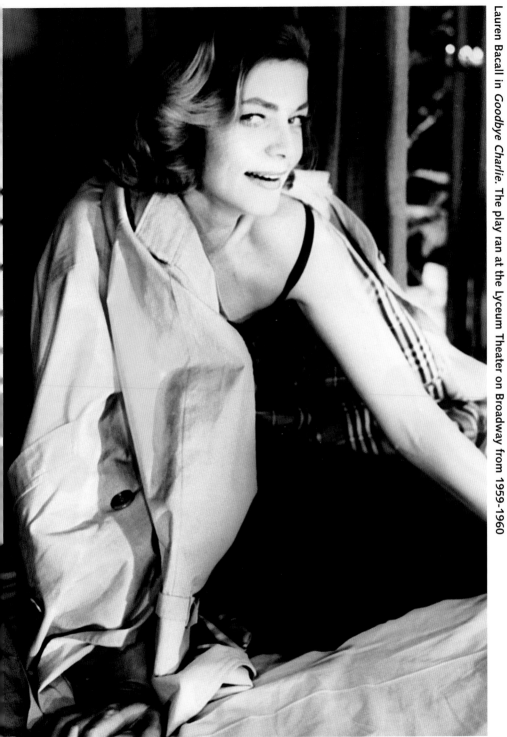

Lauren Bacall in *Goodbye Charlie*. The play ran at the Lyceum Theater on Broadway from 1959-1960

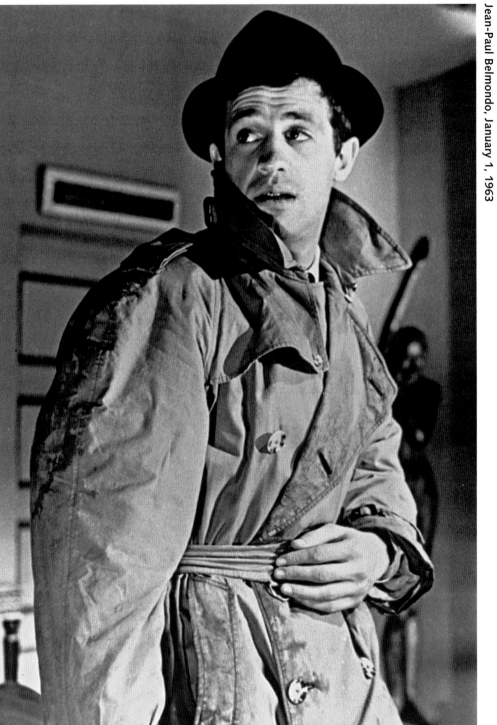

celebrate this close link with the film industry, Autumn 2007 saw the brand introduce a unique collection, Vintage Hollywood, a capsule range of trench coats recreating the classic styles that the legendary Regent Street brand had custom-made for the movies over the years. Each coat encapsulated the glamour of Hollywood's golden era in stylish rainwear.

But for a film that explains the trench coat and the far-from-glamorous culture from which it came, nothing beats *The Life and Death of Colonel Blimp.* This Powell and Pressburger film of 1943 deals with a veteran of the Boer and First World wars coming to terms with the ungentlemanly way in which the Second World War is being fought. It is a masterpiece and quite possibly the finest war film ever—given the complexity and sensitivity with which it handles its subject, while also fulfilling a propaganda role.

In the part of the film dealing with the First World War, the upper-class Candy wears a pale trench coat, which he buckles and buttons himself as if

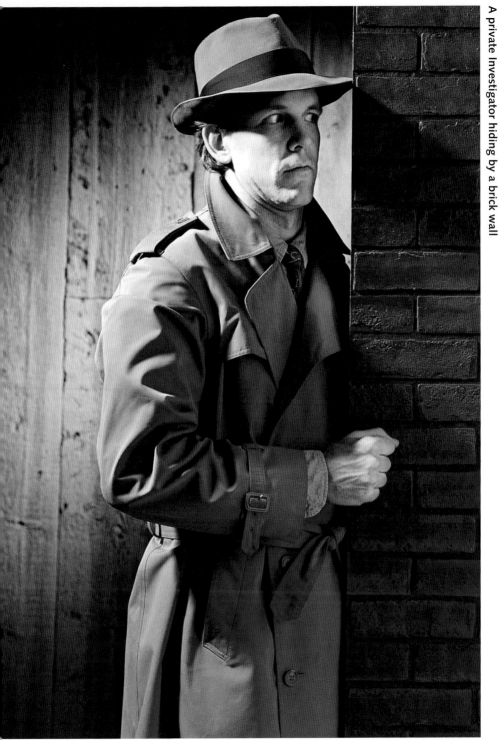

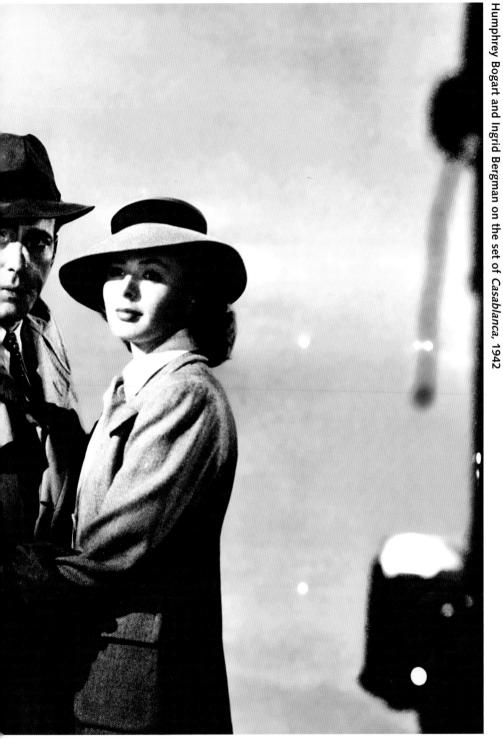

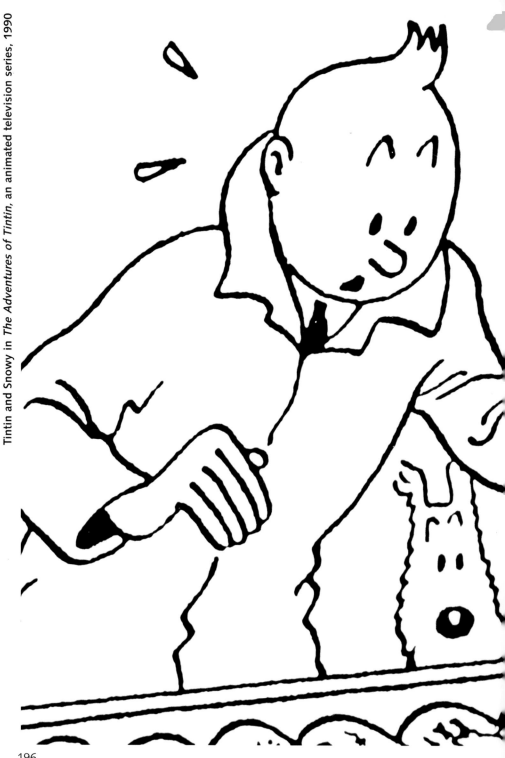

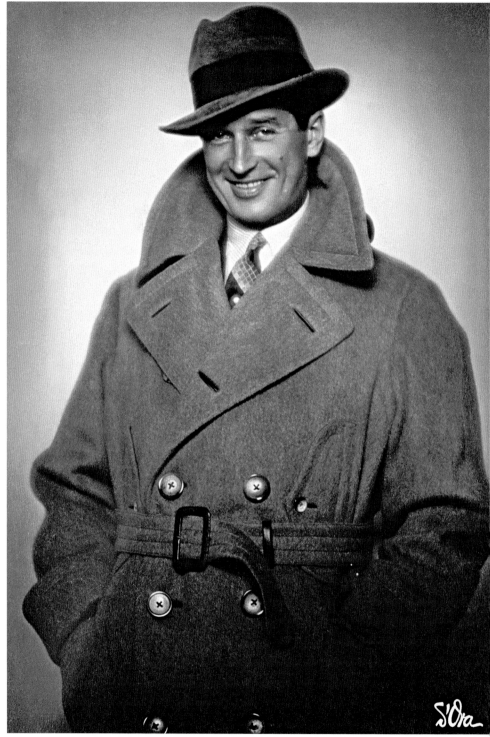

S'Ora

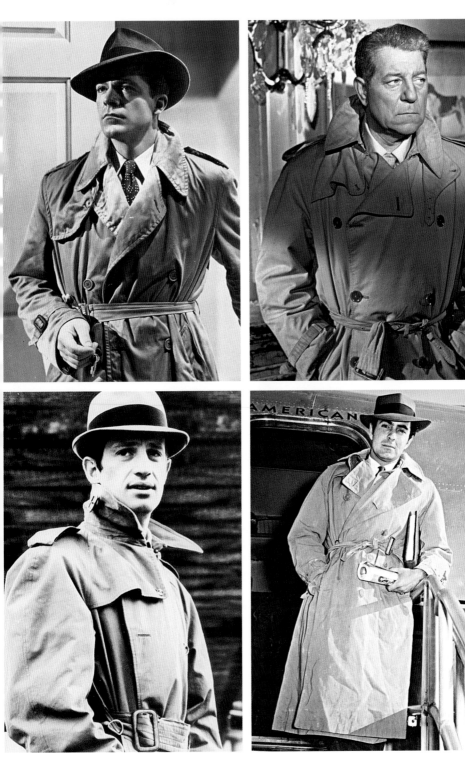

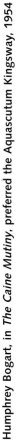Humphrey Bogart, in *The Caine Mutiny*, preferred the Aquascutum Kingsway, 1954

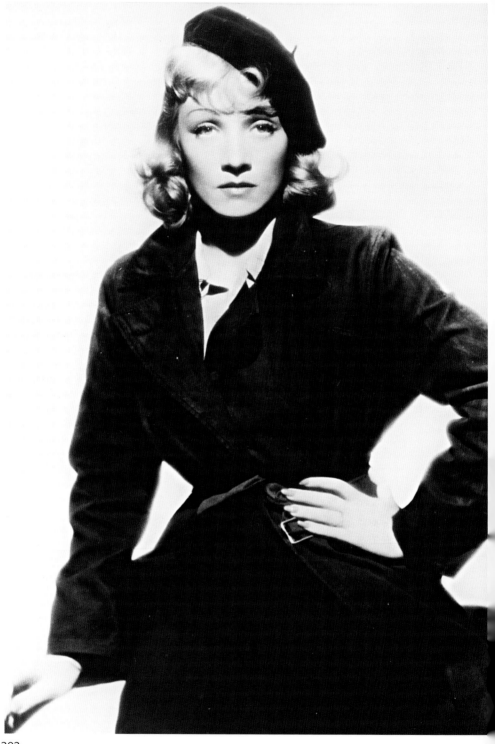

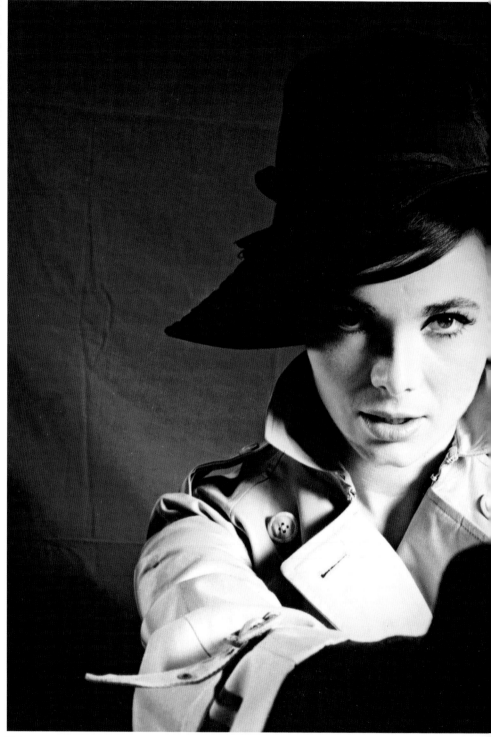

getting into and out of a suit of protective clothing. All the details are there—storm flaps, throat latch and the lot. In one scene, the trench-coated Candy is seen opposite a character called Van Zijl wearing a sheepskin gilet reminiscent of a canadienne.

Every generation has its favourite trench coat movie moment. Perhaps it's Bogart or Audrey Hepburn in *Breakfast at Tiffany's*, Meryl Streep in *Kramer vs. Kramer*, Warren Beatty in *Dick Tracy*, or Brad Pitt in *Ocean's Twelve*. However it is used, a trench adds something to a picture.

Whether it's worn by George Peppard in *Operation Crossbow* or George C. Scott in *Patton*, a trench helps establish a suitably martial atmosphere. Nor is it just the good guys who wear trenches. The menace of the Nazi leather trench is exploited in the *Indiana Jones* series of films, providing the appropriate level of period menace as Harrison Ford battles against the servants of a Hitler-esque administration obsessed with the occult.

The trench is used as a mood enhancer in films

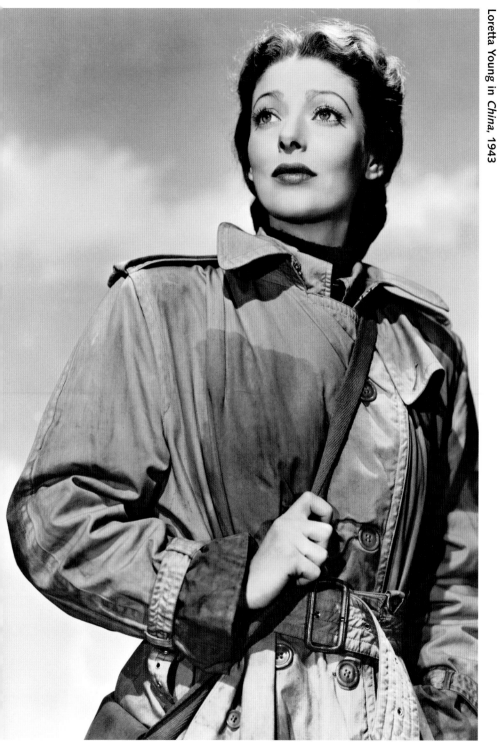

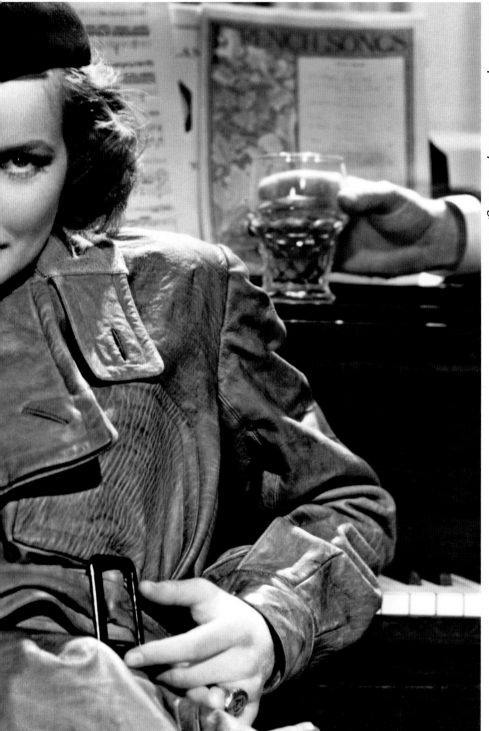

Katharine Hepburn in *Christopher Strong*, 1933

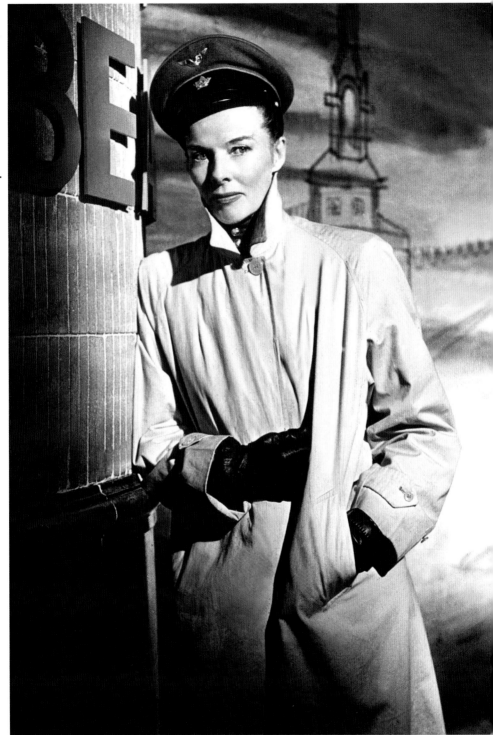

Katharine Hepburn in *The Iron Petticoat*, 1956

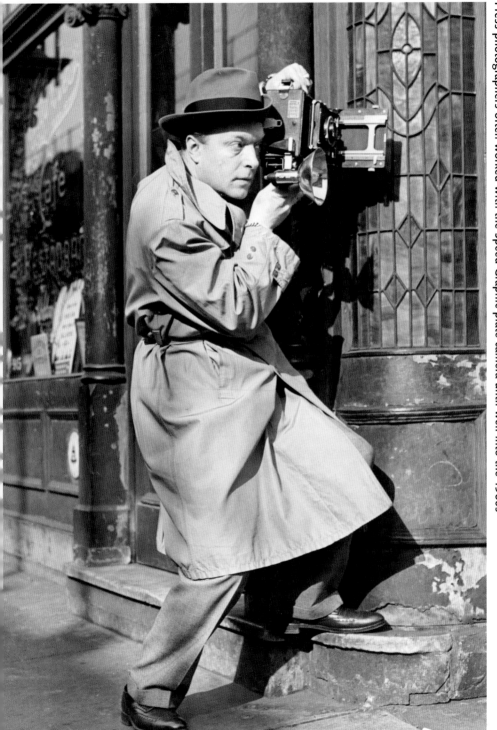

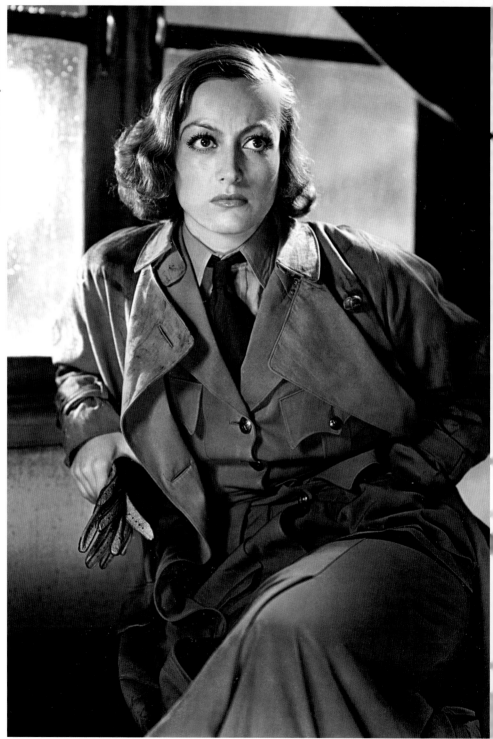

Joan Crawford in *Today We Live*, 1933

During the 1940s
the trench coat
was made available
to the general public. It was at
this point that Aquascutum
won fashion acclaim
for its trench coats. The look
was soon an intrinsic part of
the Hollywood movie
wardrobe.

Aquascutum

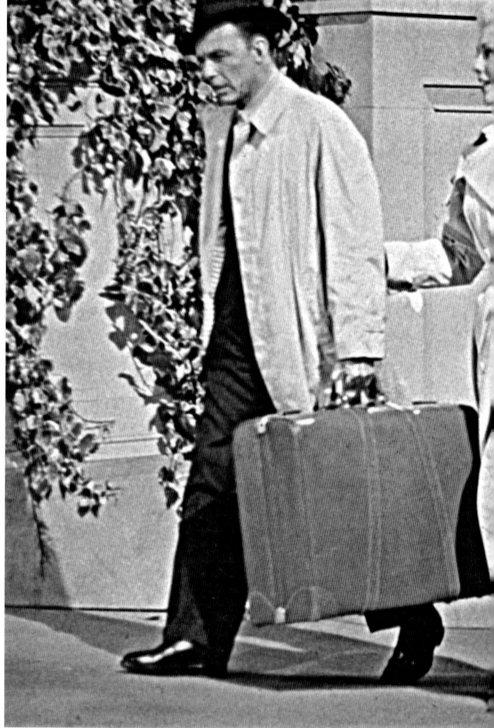

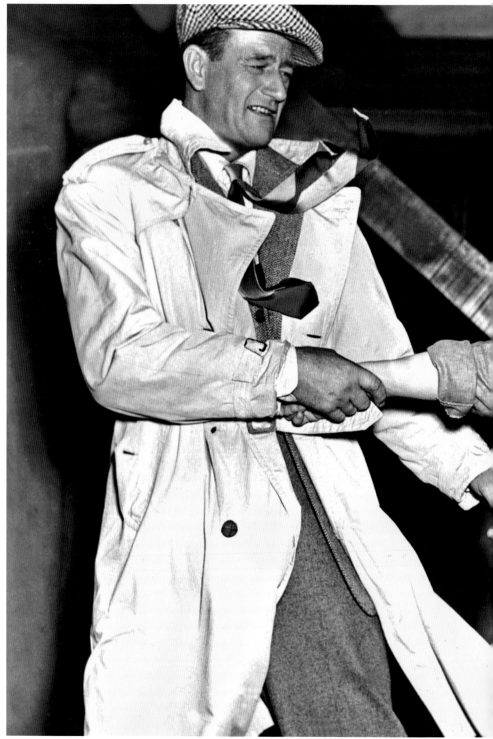

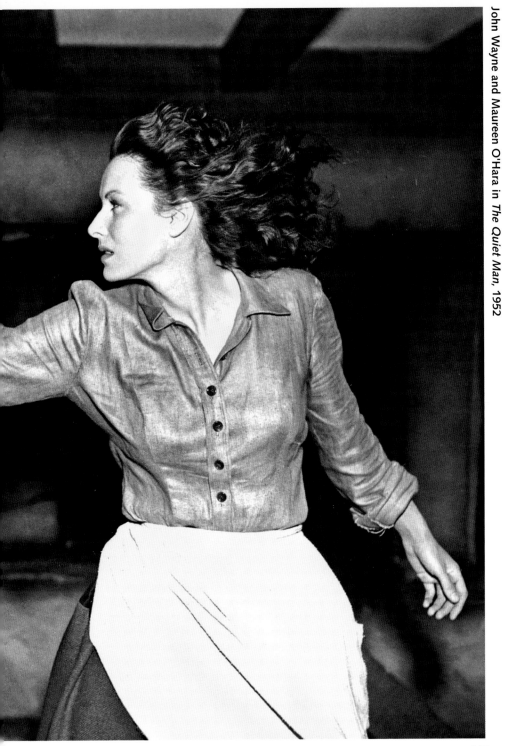

about life in occupied Europe. Typical is *The Arc of Triumph,* set in 1942 and starring a sexily trenched Ingrid Bergman and the trench-clad Charles Boyer. Likewise, in *Casablanca*, the depiction of life among Europeans in North Africa, shadowed by the brooding menace of the war, is perfect for the trench coat.

Of course, the trench moved seamlessly from war to peace and managed to be a great favourite of leading ladies: Lana Turner wore one in *The Bad and the Beautiful,* directed by Vincente Minnelli. Minnelli obviously had a thing about women in trenches, as Cyd Charisse wore one in the Minnelli-directed *Band Wagon.*

Hitchcock, too, was a director who often cast a woman in a trench, videlicet Audrey Hepburn in *Charade* and Julie Andrews in *Torn Curtain.* These women, two of cinema's most wholesome stars, also appeared in trench coats in *Breakfast at Tiffany's* and in *The Americanization of Emily,* respectively.

Conforming to the national stereotype, French films tend to sex up the trench coat, with starlets such as

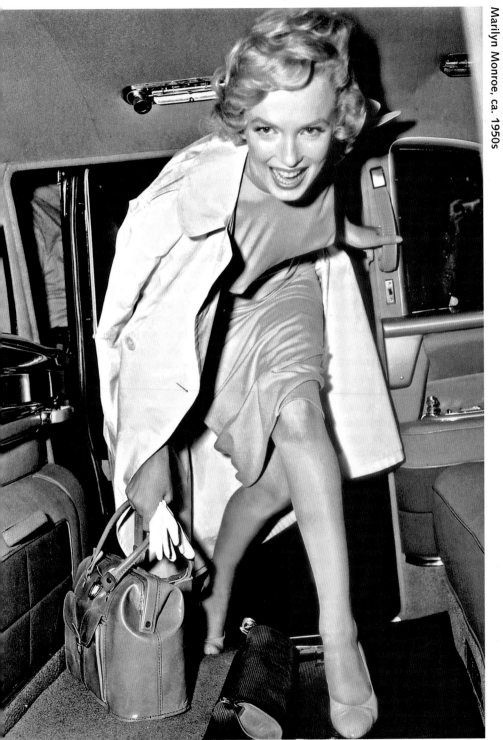

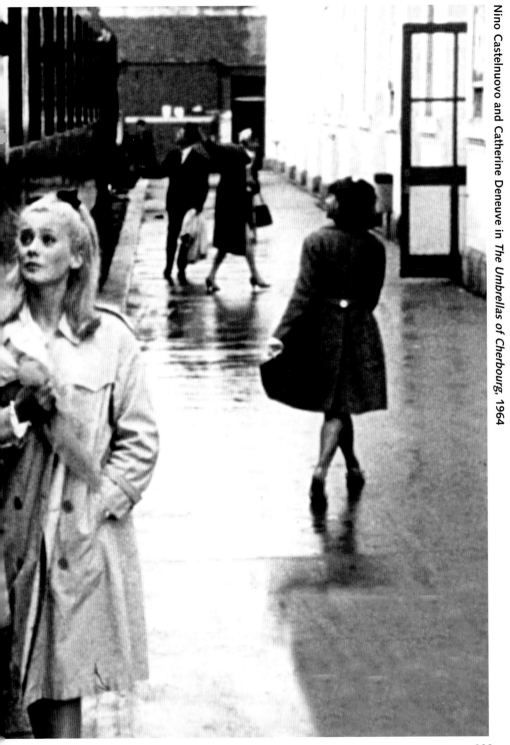

Nino Castelnuovo and Catherine Deneuve in *The Umbrellas of Cherbourg*, 1964

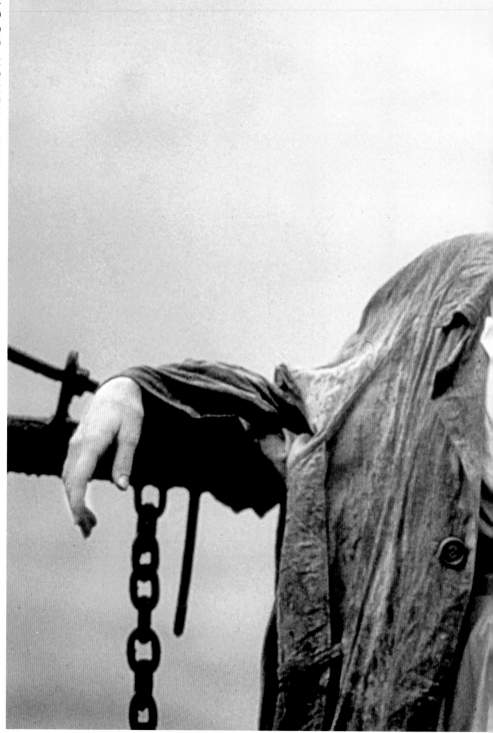

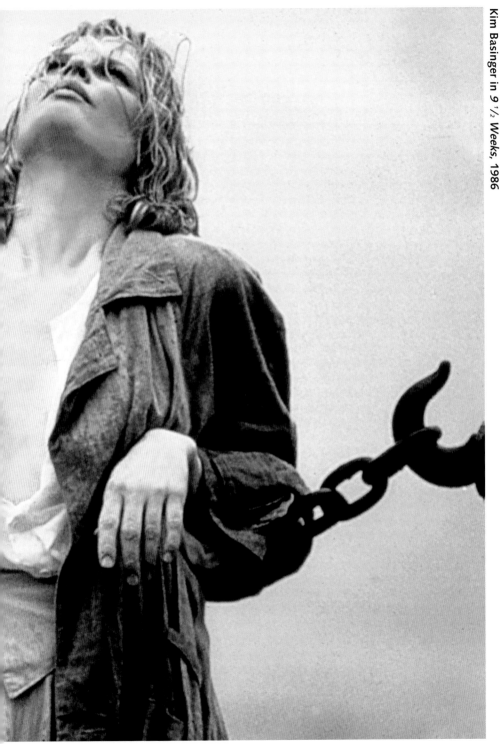

Brigitte Bardot and Catherine Deneuve appearing in them. French cinema is also responsible for an interesting subculture in cinema rainwear—the *cire noir*. This shiny raincoat, often made of PVC and belted trench style, was an absolute staple for young women appearing in sexy pseudo-intellectual films dealing with self-consciously modern issues in European cinema of the sixties and seventies. What is more, the vaguely fetishistic nature of the *cire noir* came in useful when looking for a visual shorthand that said "prostitute."

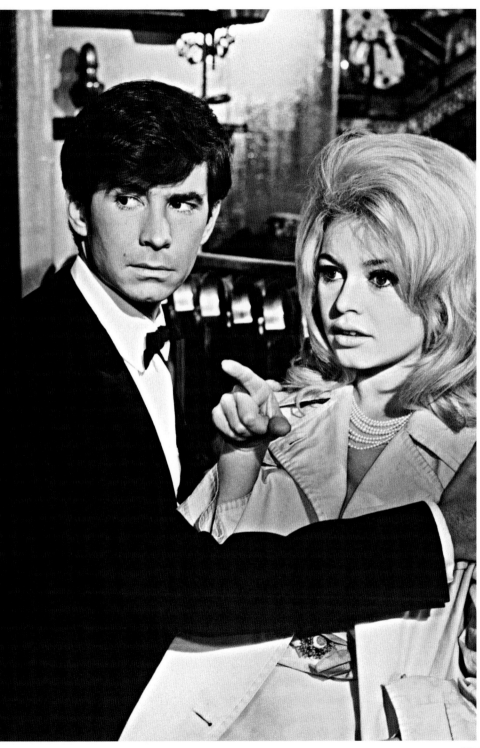

France's sex kitten Brigitte Bardot with Anthony Perkins in *Adorable Fool*, 1964

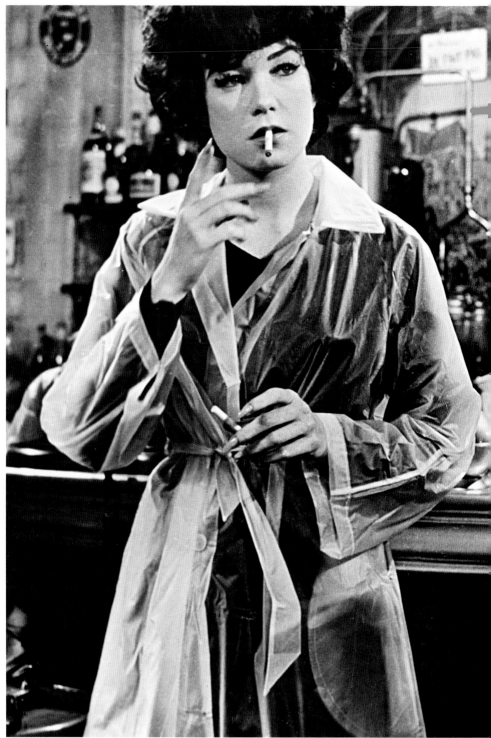

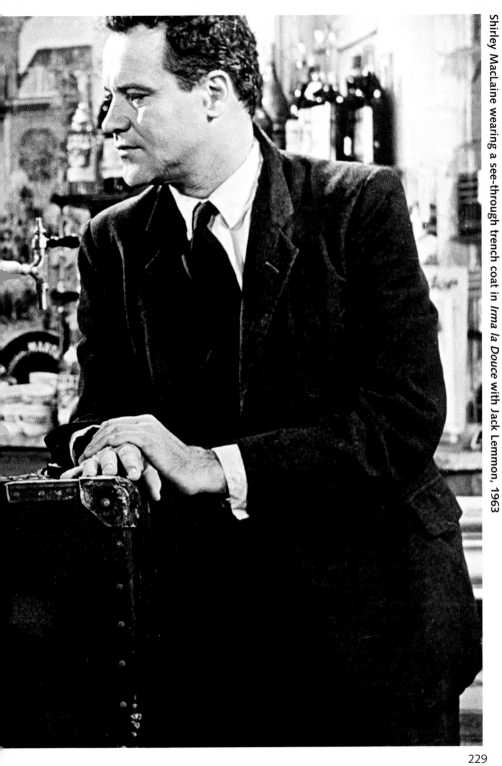

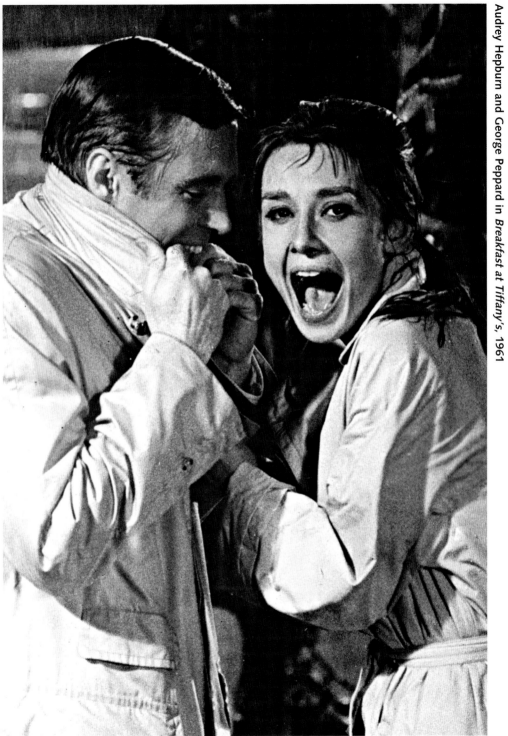

Audrey Hepburn and George Peppard in *Breakfast at Tiffany's*, 1961

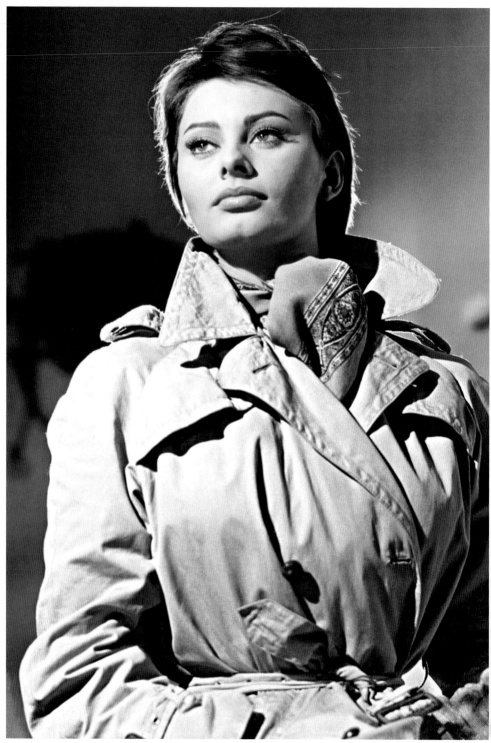

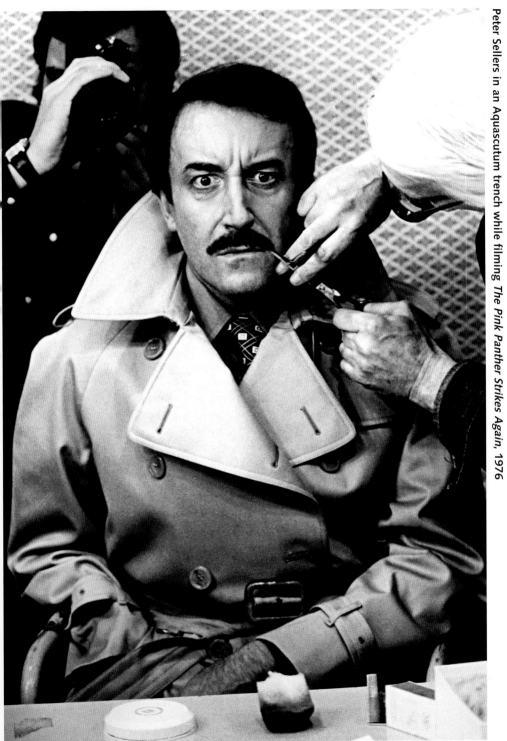

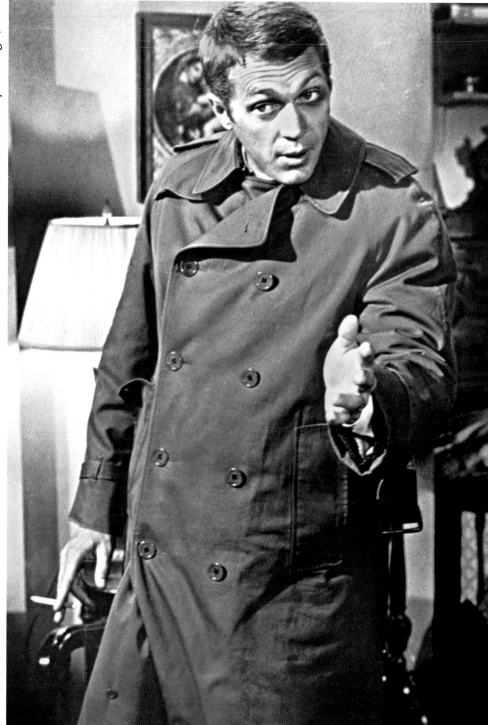

Steve McQueen in *Love with the Proper Stranger*, 1963

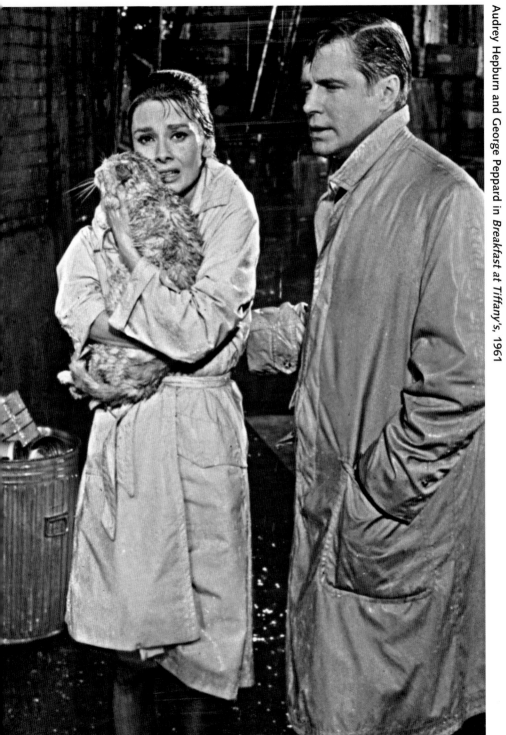

The trench coat was once a uniform— now it is a badge of individuality.

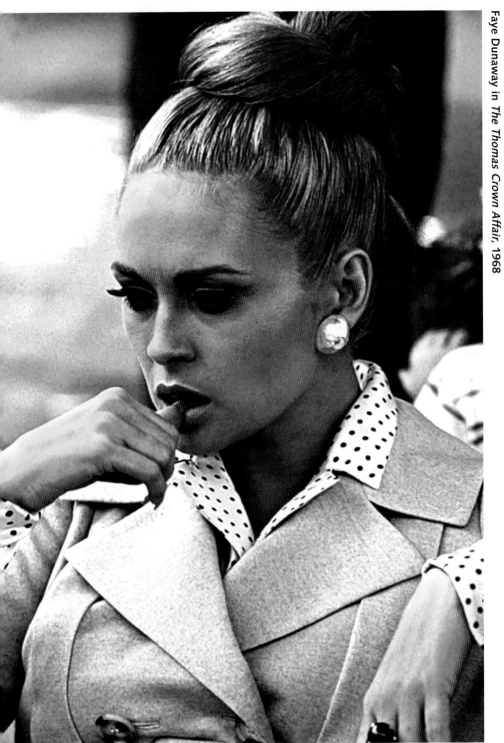

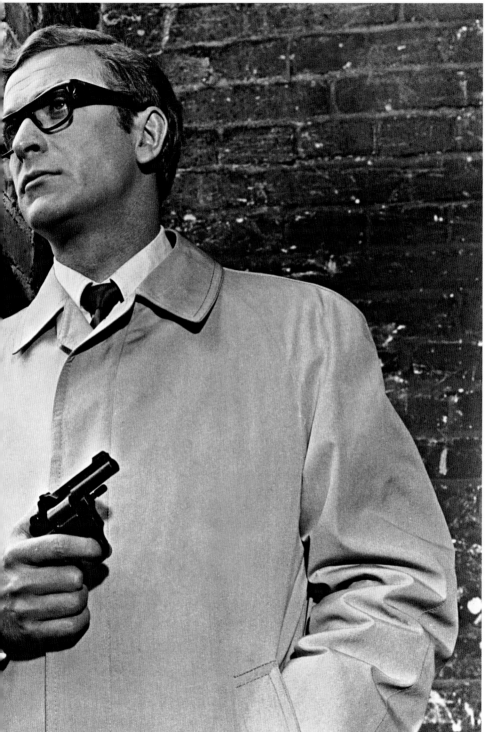

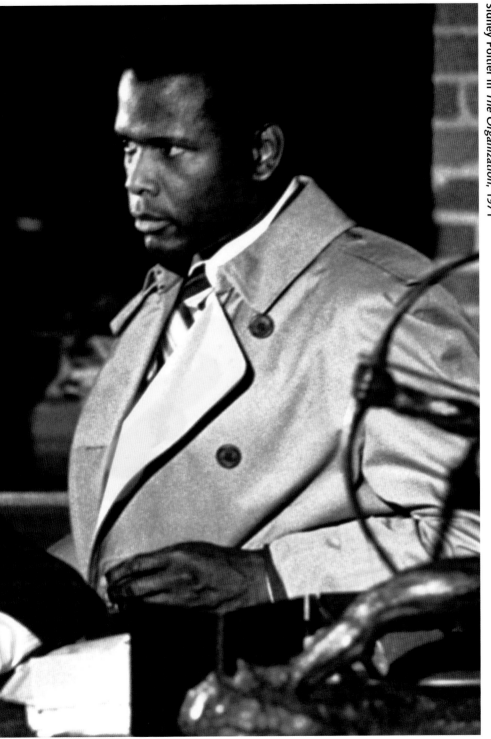

Droopy Dog in television's *Droopy: Master Detective*, 1993

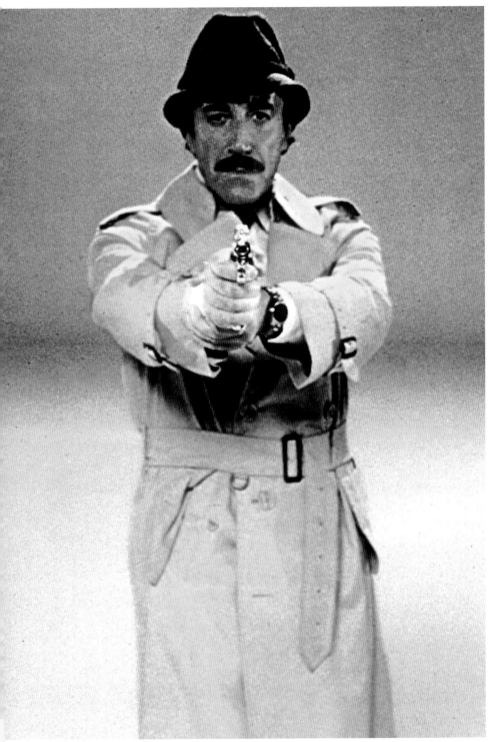

Peter Sellers in *The Pink Panther Strikes Again*, 1976

I only wear the trench coat because I desperately want to be Robert Mitchum.

Robert Stack

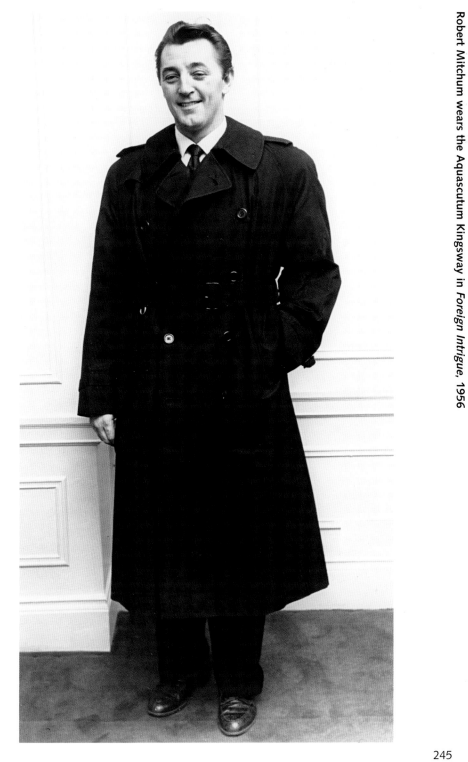

Robert Mitchum wears the Aquascutum Kingsway in *Foreign Intrigue*, 1956

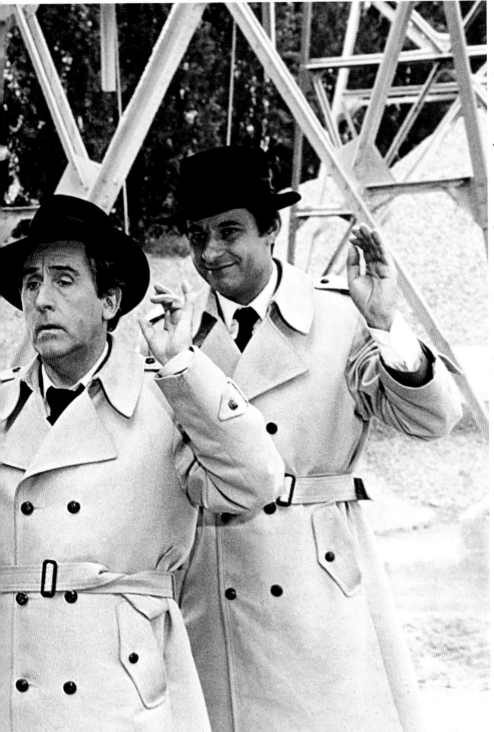

249

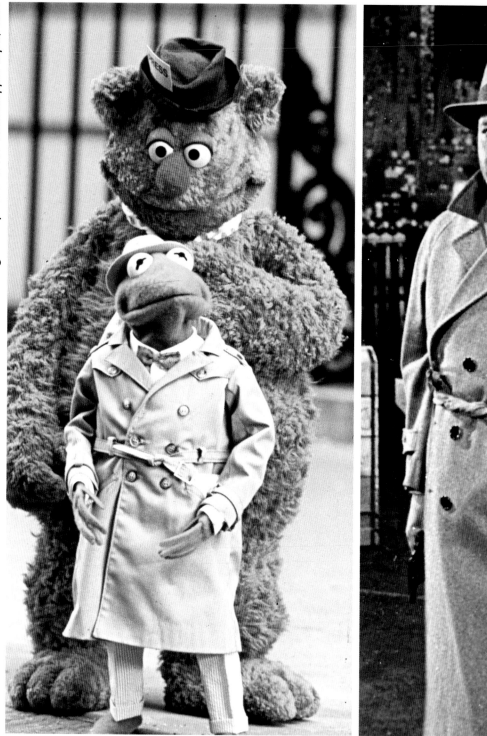

Kermit and Fozzie Bear as investigative reporters in *The Great Muppet Caper*, 1981

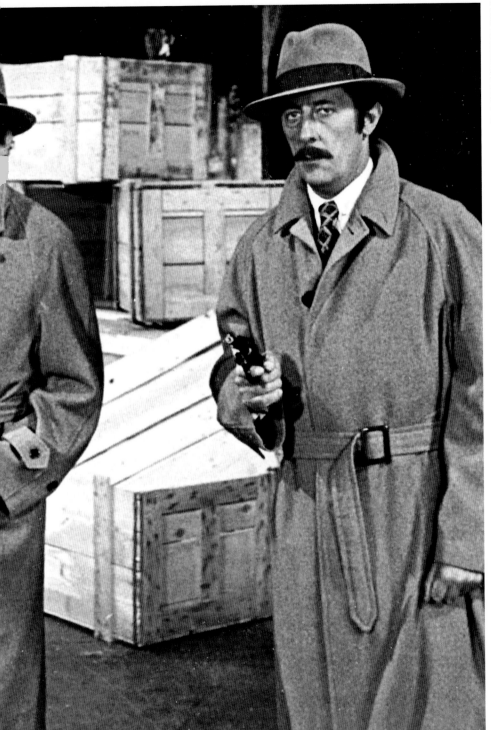

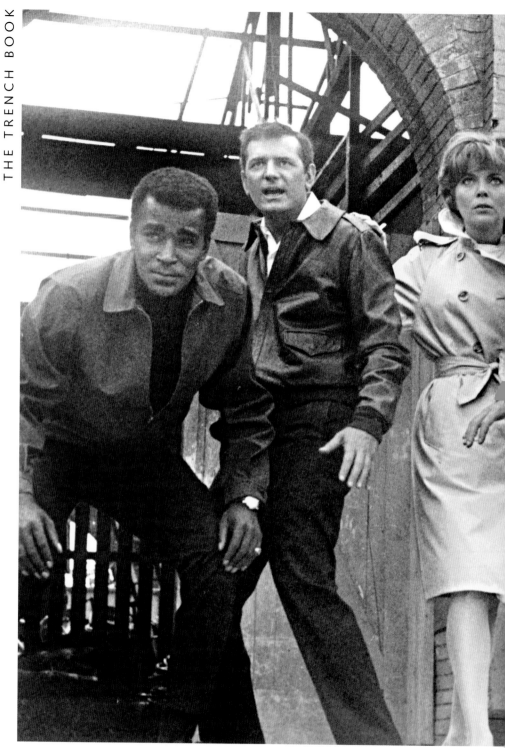

Greg Morris, Steven Hill, Barbara Bain, and Peter Lupus in the television series *Mission: Impossible,* 1966–1973

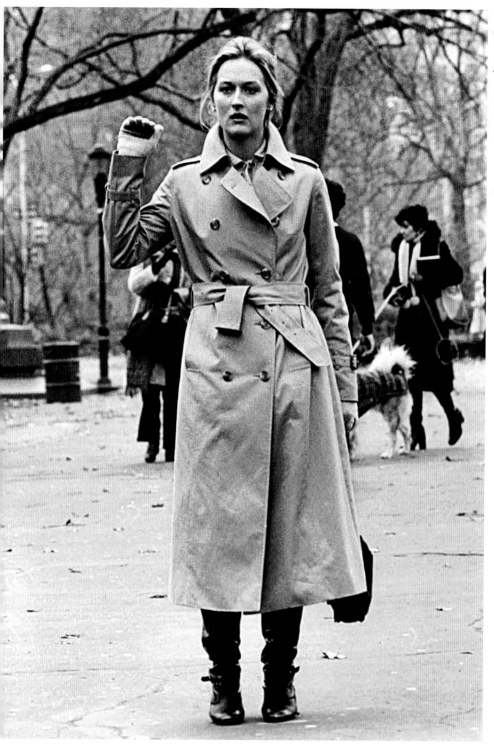

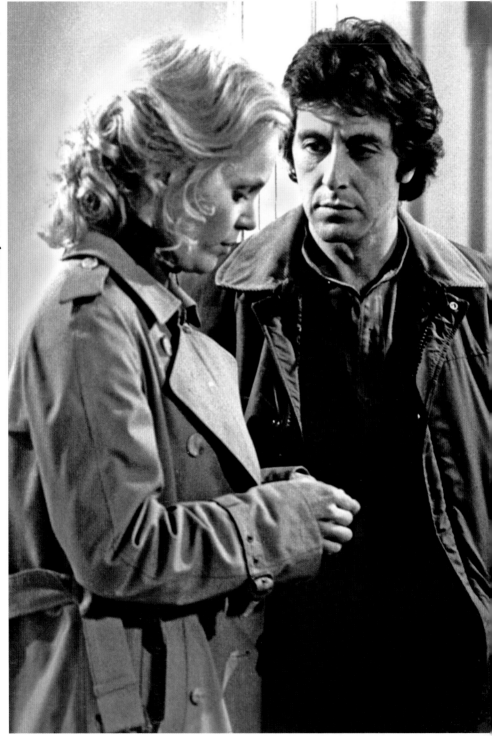

Tuesday Weld and Al Pacino in *Author! Author!*, 1982

Almost every man looks more so in a belted trench coat.

Sydney J. Harris,
Chicago Daily News

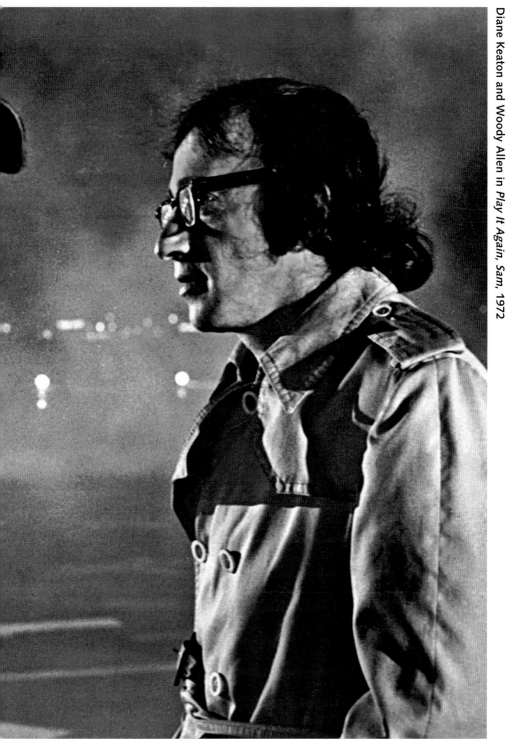

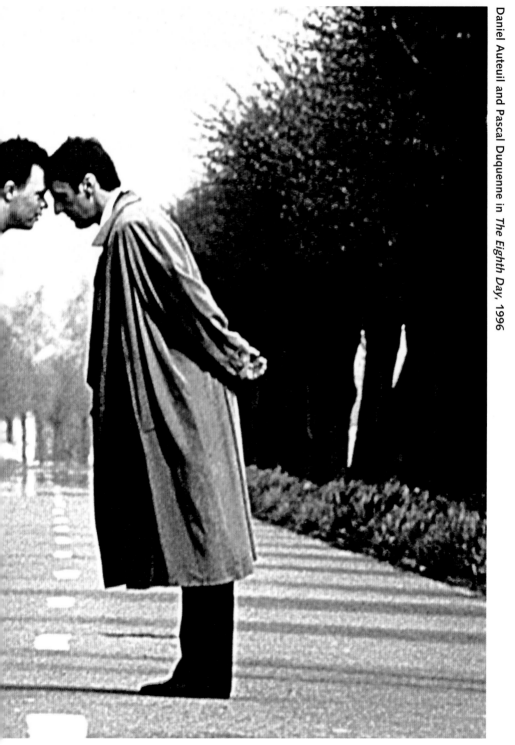

Daniel Auteuil and Pascal Duquenne in *The Eighth Day*, 1996

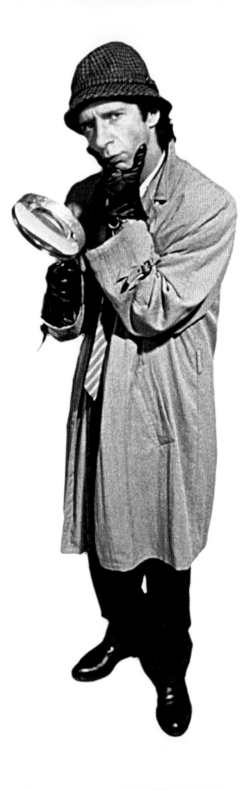

Roberto Benigni in *The Son of the Pink Panther*, 1993

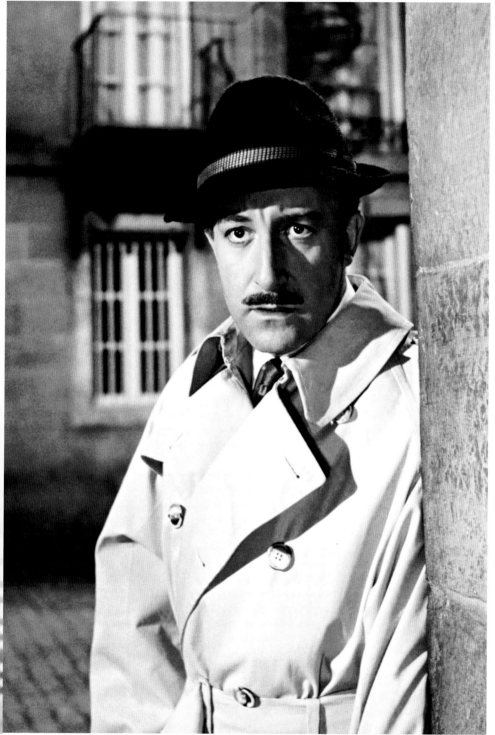

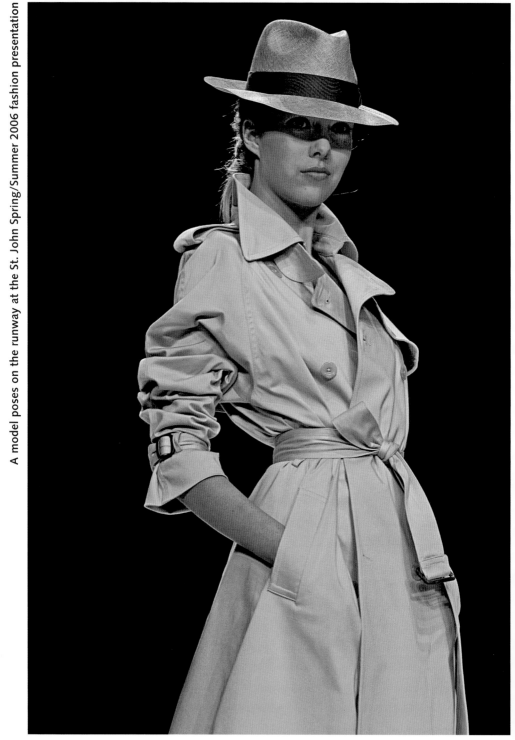

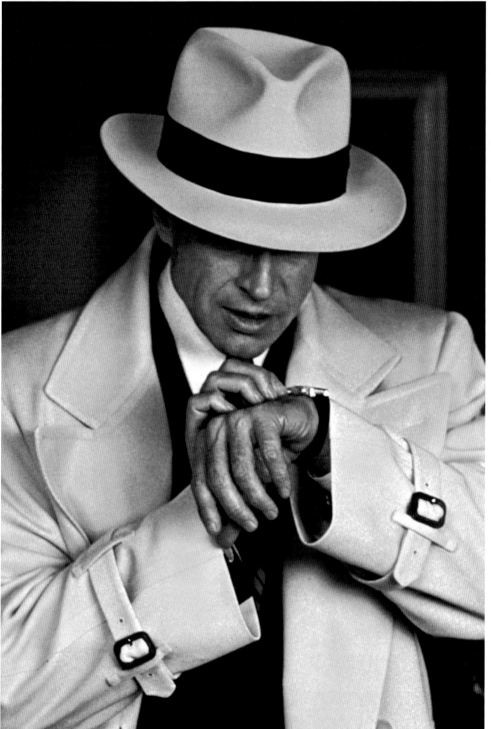

Warren Beatty in *Dick Tracy*, 1990

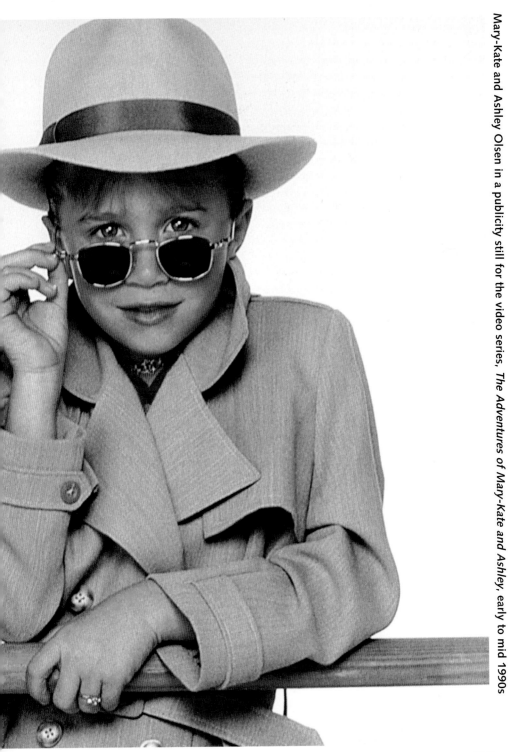

Mary-Kate and Ashley Olsen in a publicity still for the video series, *The Adventures of Mary-Kate and Ashley*, early to mid 1990s

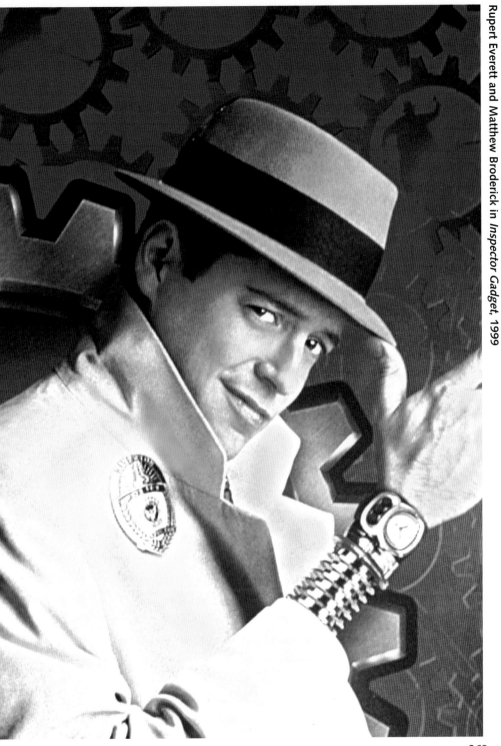

Never trust a man in a blue trench coat, never drive a car when you're dead.

"Telephone Call From Istanbul"
Tom Waits

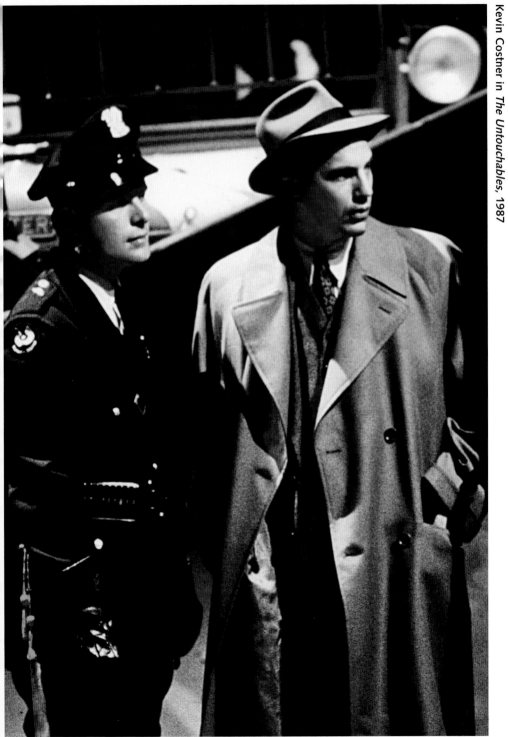

Watching the Detectives: The Private Eye

Cinema tends to adhere to various conventions: the villains of James Bond films find their headquarters explode ten minutes before the final credits, aliens never quite manage to destroy Earth, and detectives wear trench coats. It is a convention that applies to literature as much as it does to film.

A quick look at the artwork of paperback crime novels of the 1950s brings up classics such as *Dark Duet*, a novel of counterespionage that has a trench-coated hero delivering a right hook to a pistol-toting villain while a scantily clad woman occupies the foreground. The formula of a trench coat and the semi-naked female form is also well-rehearsed on the cover of the 1956 novel *A Beauty for Inspector West*, by John Creasey. But while it might have been acceptable, if not desirable, to have women presented in a state of deshabille, it seems that connoisseurs of Creasey's oeuvre liked to see the inspector properly trenched up, as many covers show him thus attired.

The trench is something that detectives share in common with journalists. Both professions enjoy a slightly dubious reputation; they involve ferreting out information and standing around in the pouring rain with the collar of a trench coat turned up, trying not to get noticed. For instance, when Michael Caine decides to do a bit of investigation of his own in the cult gangster movie *Get Carter*, he wears trench. Bearing in mind that it doesn't rain a great deal in Los Angeles, it

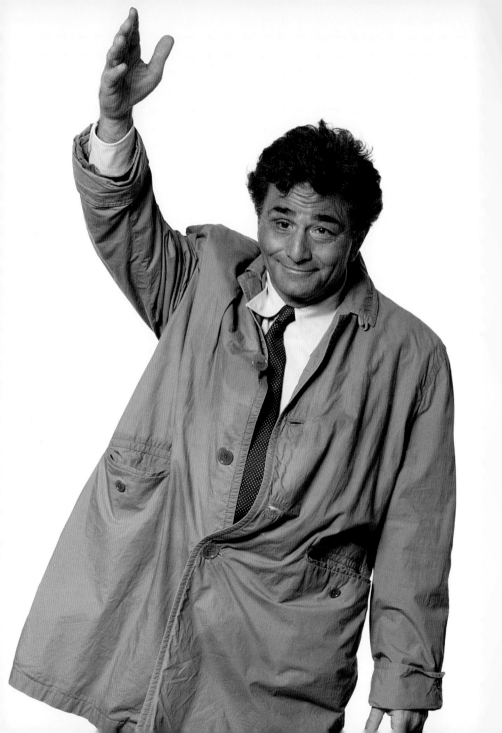

remains something of a mystery why the trench coat should be such a staple of film noir. Yet it is almost a requirement of the genre, as much as, say, the crossdressing mistaken identity in a Shakespearean comedy or the bloodbath in a Tarantino film.

The trench coat also seems to fix itself onto certain actors and remain there. Humphrey Bogart, for one, seemed to be under contract to wear a trench in every film he ever made...well, almost. Certainly, Aquascutum was well aware of the marketing potential of the *Casablanca* star. For the 1953 film *Beat the Devil,* in which Bogey starred with Peter Lorre and Gina Lollobrigida, Aquascutum made lobby cards and window displays showing Bogart wearing their perennially popular Kingsway-style trench coat.

There is, of course, only one actor who comes close to challenging Bogey's position as the trench coat star, and that is Peter Sellers in his incarnation as Inspector Clouseau. That a bumbling, bungling fool with an atrocious French accent and an unrivalled aptitude for accidents should become a style god is ample testimony to the power of a good trench coat. Such is the allure of the inspector that according to the March 1976 issue of *Vogue,* Peter Sellers starred in *The Return of the Pink Panther* alongside an 'Aqua 5 proof fawn cotton/polyester gabardine trench'[1] costing 'about £78'[2] from Aquascutum.

Preceding page:
Peter Falk, ca.
November 1988.

Opposite:
John Phillip Law
in *Danger:*
Diabolik, 1968.

Following pages:
Left: A man
wearing a trench
coat, carrying a
satchel, 1955
Right: Man in hat
and trench coat,
standing in the
rain, 1999.

1. *Vogue,* March 1976, pp. 94-95.
2. Op. cit.

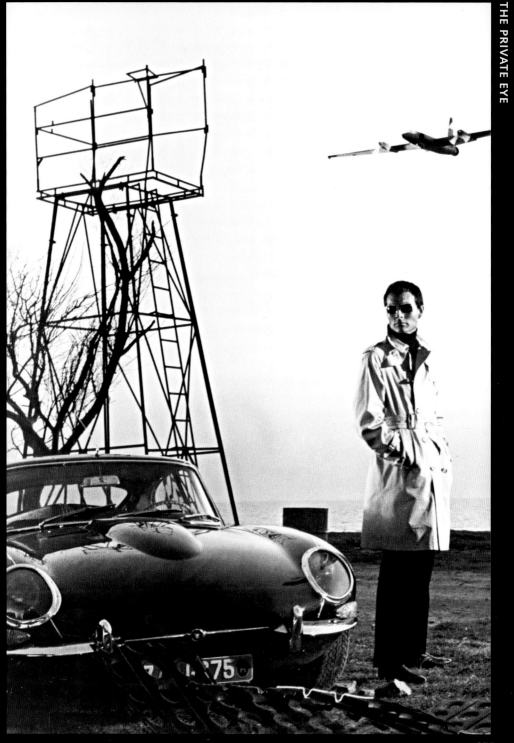

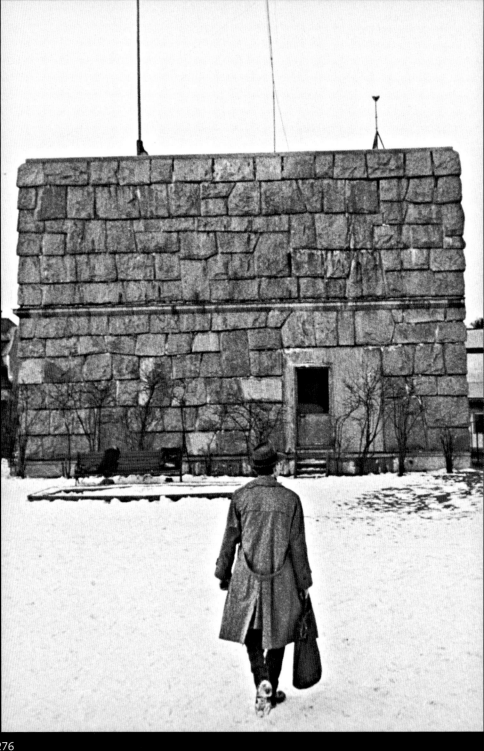

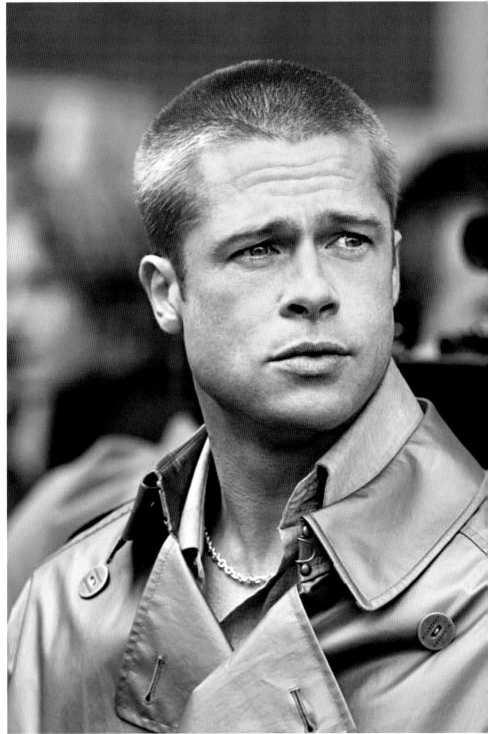

Brad Pitt on set of the film *Ocean's Twelve*, 2004

A Preppy
Love Affair:
America
and the Trench

The American view of England
has always been quite complex.
Ever since England rid the coun-
try of George III as its ruler,
following a little colonial
disturbance known officially as
the American War of
Independence, the United
States, or at least a considerable
number of its inhabitants, have
been doing their best to mimic
British style, manners, customs—
from punk rock to hunting pink.

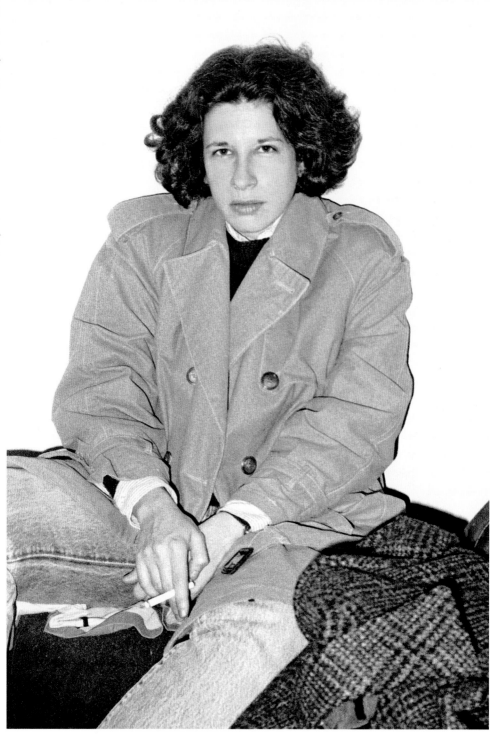

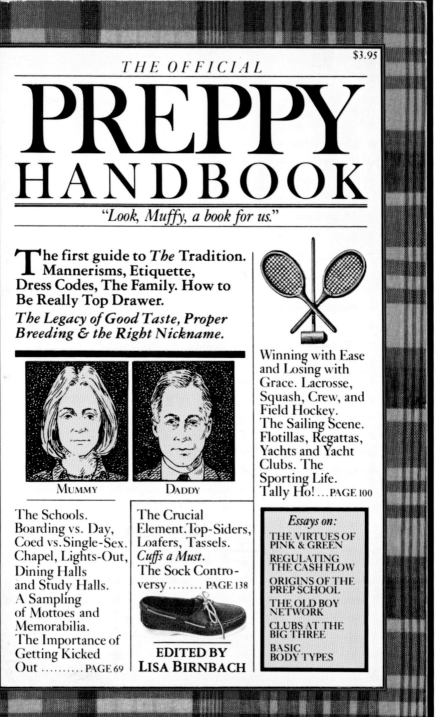

$3.95

THE OFFICIAL

PREPPY HANDBOOK

"Look, Muffy, a book for us."

The first guide to *The* Tradition. Mannerisms, Etiquette, Dress Codes, The Family. How to Be Really Top Drawer.
The Legacy of Good Taste, Proper Breeding & the Right Nickname.

MUMMY DADDY

Winning with Ease and Losing with Grace. Lacrosse, Squash, Crew, and Field Hockey. The Sailing Scene. Flotillas, Regattas, Yachts and Yacht Clubs. The Sporting Life. Tally Ho! ...PAGE 100

The Schools. Boarding vs. Day, Coed vs. Single-Sex. Chapel, Lights-Out, Dining Halls and Study Halls. A Sampling of Mottoes and Memorabilia. The Importance of Getting Kicked Out PAGE 69

The Crucial Element.Top-Siders, Loafers, Tassels. *Cuffs a Must.* The Sock Controversy PAGE 138

EDITED BY LISA BIRNBACH

Essays on:
THE VIRTUES OF PINK & GREEN
REGULATING THE CASH FLOW
ORIGINS OF THE PREP SCHOOL
THE OLD BOY NETWORK
CLUBS AT THE BIG THREE
BASIC BODY TYPES

The Official Preppy Handbook, the bible for argyle-sock, Fair Isle-sweater, grosgrain belt, and polo shirt-wearing teens of the 80s

W.H. Fraser , T.C. Cashen, and C.J. Goff after a meeting with President Truman, in an effort to head off a railroad workers strike, 1940

Like black tie, a trench coat always improves the way a man looks.

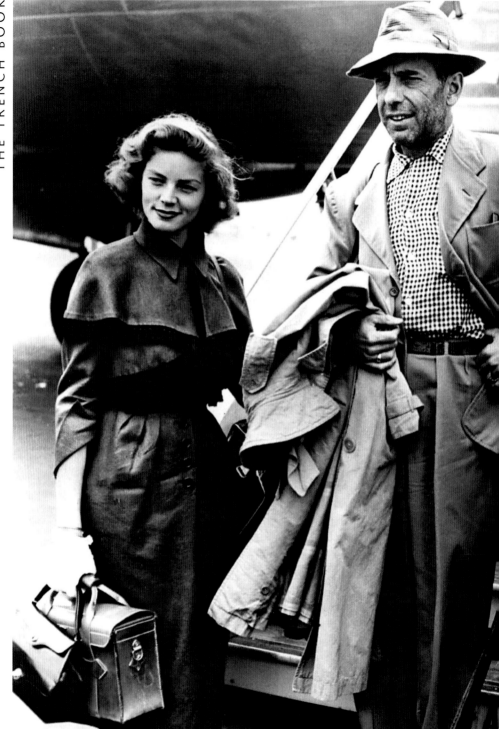

Lauren Bacall, Humphrey Bogart and Katharine Hepburn in *The African Queen*, 1951

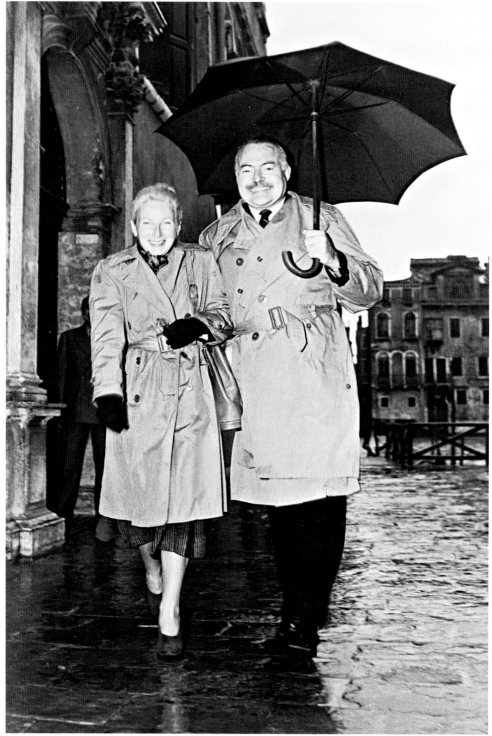

Ernest Hemingway with his fourth wife Mary in Venice, 1954

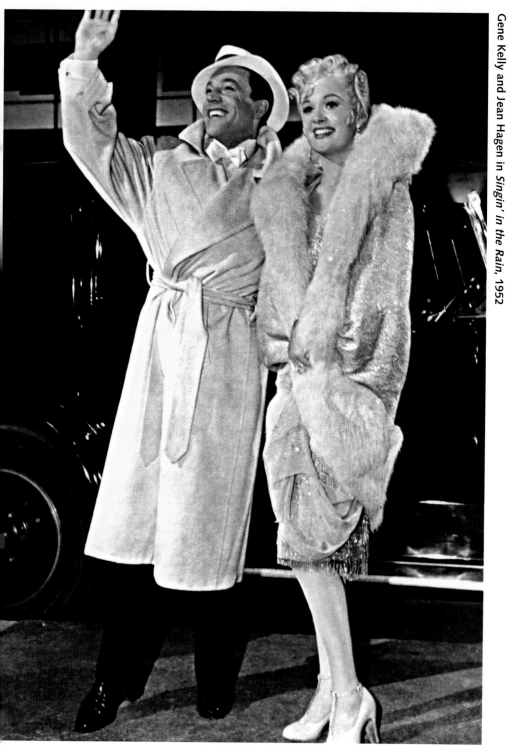

Among the most Anglophile of all Americans are the preppies, the aristocrats of a so-called classless society—and they love the trench. Think about it. the trench coat has all of the elements that a preppy truly loves: heritage, Britishness, a slightly formal glamour (like black tie, a trench coat always improves the way a man looks), and a bold check. Long before the checked linings of trench coats were used to decorate everything from luggage to bikinis, preppies are addicted to them—doubtless an atavistic yearning for the plaids, district checks, and tartans of the Scottish Highlands, whence they would like to think their ancestors came.

The trench is also a very American business coat. In the absence of jousting, or duels fought with foils or pistols, business has become the adversarial arena in which it is indeed the winning, not the taking, that counts. The trench is a coat of armour that protects its wearer, giving him the courage to do what those who are not masters of the universe would never be capable of. Just as it was worn by captains in the trenches, so the

wearer, consciously or subconsciously, hopes that a little of the captain—captain of industry, that is—will rub off on him. It inspires confidence, authority, and trust. After all, Gordon Gekko and John DeLorean sure looked awfully convincing in trench coats.

There has also been a completely inexplicable American tradition of romanticising the British climate. Take the brand name London Fog under which many fine trench coats have been sold. I daresay that whoever thought of such a name must have felt they were evoking a tourist brochure image of mist swirling around the ankles of trench coat wearers as they flag down black cabs driven by cheeky, chappy cockneys who say, "Where to, Guv?"

However, Londoners did not see it quite that way. When it comes to smog (smoke + fog = smog), London in the first half of the twentieth century could teach modern-day Los Angeles a thing or two. Pea soupers, thick, choking yellow fogs, would envelop the city in an impenetrable

Woody Allen in *Broadway Danny Rose*, 1984

shroud, reduce visibility to a few paces, and cause motor vehicles to move at a walking pace. London all but came to a halt. As the city was heated by tens of thousands of coal fires, pollution was a major contributor. With the advent of motor cars, this only worsened. Nevertheless, these fogs were accepted as an inalienable, unpleasant and inconvenient part of life in London until December 1952.

It had been particularly cold and London was keeping warm the only way it knew how: throwing more coal on thousands of domestic fires. Then on December 5, a foul acrid fog smothered the capital. Water condensed around particles of tar and sootcausing a reaction with the sulphur dioxide present in the air causing a sort of acid rain. As a result, visibility was terrible, traffic halted, cars were abandoned in the middle of the road, and buses were led by conductors inching their way through the dense smog. Conditions deteriorated to such a degree that theatres and cinemas had to shut down

because patrons could not see the stage or the screen It was the better part of a week before the fog lifted, having claimed the lives of at least 4,000 Londoners and an estimated 12,000 who died later from related causes. As well as being the name of an American raincoat, London fog was a lethal environmental disaster.

After such a dreadful loss of life, things had to change. The Clean Air Act of 1956 and other successive legislation ensured that London would never be afflicted so terribly under the same circumstances ever again. By the twenty-first century, the streets of London were pea souper free, and the trench coats of London Fog were bold, fashion forward affairs in strong vibrant colors—rather than the classic pea soup colored raincoats of old.

The Royal Trench

Before there were movie stars, soap stars, rap stars, reality TV stars, and just plain famous-for-being-famous stars, there was royalty. And in terms of leading fashion, royalty was, unquestionably, there first.

Even before the days of mass communication, members of the royalty were known by sight to every one of their subjects. A king, queen, tsar or emperor appeared on coins and stamps long before movies, MTV, and the Internet conspired to make just about anyone a household name. In particular, the British Royal Family has long made a heroic contribution to the world of fashion, from Edward VII inventing the dinner jacket (while he was Prince of Wales) to Lady Diana's pie-crust collars, which became popular on both sides of the Atlantic in the glamorous 1980s.

The Aquascutum archives have a picture of King Edward VII wearing an Aquascutum overcoat with cape sleeves in a Prince of Wales check. He granted the Regent Street firm his Royal Warrant in 1897. Later, his son George V reigned as king of England during the First World War, the time of the birth of the trench coat. Aquascutum's Edwardian advertising is proudly headed with the words, "By Special Appointment to His Majesty the King" and "H.R.H Prince of Wales." Between the wars, the style-conscious Prince of Wales (later Edward VIII and Duke of Windsor) was

1. *Daily News*, Wednesday, April 7, 1965, reprinted in *An Elementary History of a Great Tradition*.

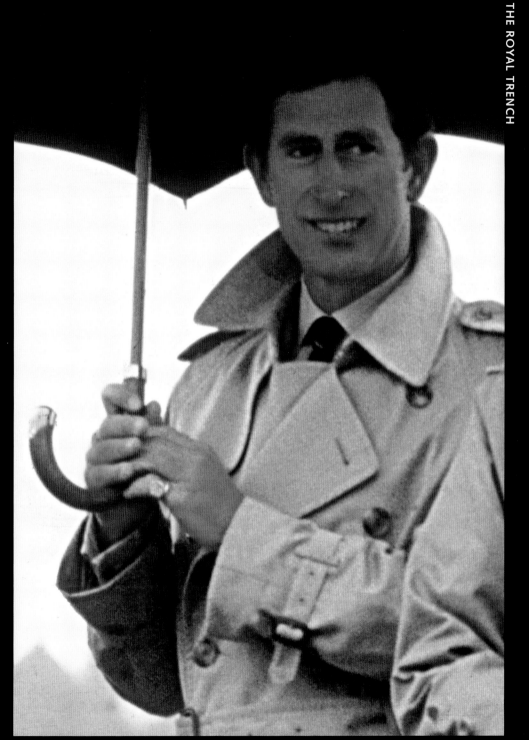

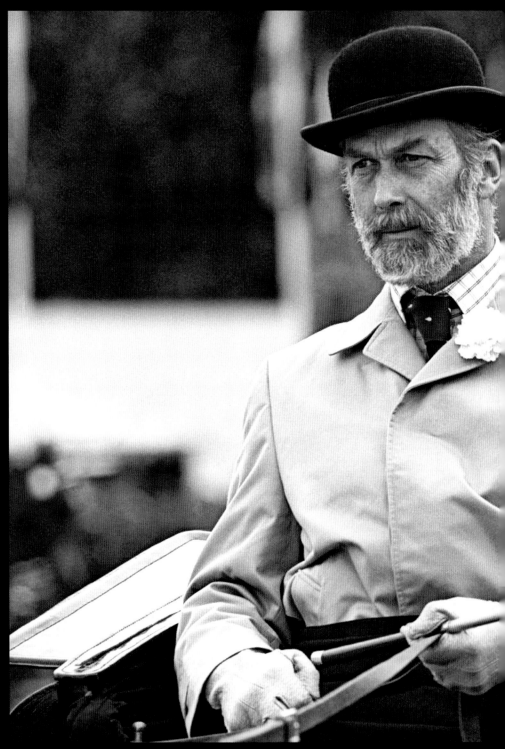

photographed wearing Aquascutum and by the middle of the century, "Aquascutum was also granted their fifth Royal Warrant by her Majesty Queen Elizabeth, the Queen Mother." Moreover, Aquascutum has also picked up numerous Queen's Awards for export achievement, the Oscars of British Industry.

But then, Burberry is no slouch in the Royal Warrant stakes either. The company may not have got off to such an early start as its Regent Street rival, but in 1955 it hit the jackpot when it was awarded a Royal Warrant from the monarch and announced, "By appointment to Her Majesty the Queen, Weatherproofers Burberrys Limited." And in 1989, the style-savvy Prince of Wales added his approval in the form of a Royal Warrant.

Today, the institution monarchy is looked upon in a less reverential light than in the last century. However there remains immense affection for the Queen, and her use of the trench coat demonstrates the impressive reach of the garment that has permeated every aspect of British life and society.

page 297:
15th June 1983:
Charles, Prince of
Wales, on holiday
in Nova Scotia.

Preceding pages:
May 14, 1995,
Prince Michael
of Kent at Royal
Windsor Horse
Show.

Following pages:
Left: The Queen
with Margaret
at Badminton,
in 1971.
Right: At the
Badminton Horse
Trials, in 1962,
Princess Margaret
(with an umbrella)
with the Queen,
Lord Snowdon and
Prince Charles in a
haycart watching
the cross country
course.

2. *The History of Aquascutum. Celebrating 150 Years of Pure British Style*, ca. 2001. p.8

**Aquascutum owes
much of its success to
the support offered by
the Royal Family.
In 1897, H.R.H the Prince of
Wales (later King Edward II)
granted Aquascutum
its first Royal Warrant.
This was followed by
an award in 1911
from King George V
and another in 1920
by H.R.H Prince of Wales
(later the Duke of Windsor).**

Aquascutum

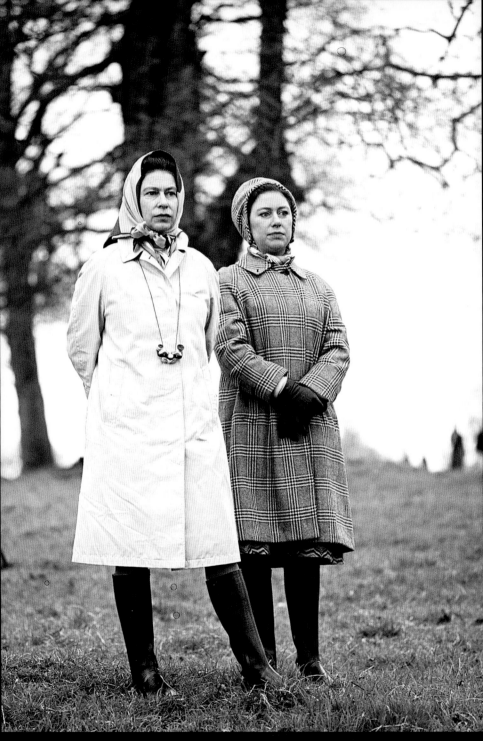

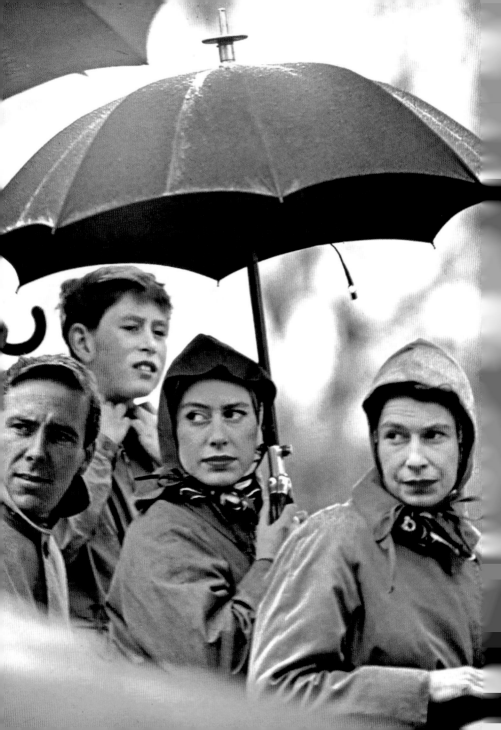

Trench Coat Mafia

MYTHOLOGY

"Although the investigation identified Harris and Klebold as being 'members' of the TCM, it appears that the Trench Coat Mafia was a loose, social affiliation of former and current Columbine High School students with no formal organizational structure, leadership or purpose such as that typically found in traditional juvenile street gangs. Contrary to reports following the Columbine shootings, there is no evidence of affiliated Trench Coat Mafia groups nationwide."

-Jefferson County Sheriff's Office, Colorado

The thirteen murders of April 20th, 1999 at Denver's Columbine High School were a dreadful and chilling symptom of the nihilistic tendencies of Generation X running out of control.

It is easy to ascribe glib sociological "reasons" for this horrific violence. One of the immediate reflex reactions was to identify the perpetrators, Eric Harris and Dylan Klebold, as members of a racist, right-wing cadrew of new-Nazi's, obsessed with Goth music, video games and guns—who set themselves apart from the mainstream by wearing trench coats. That an early news report

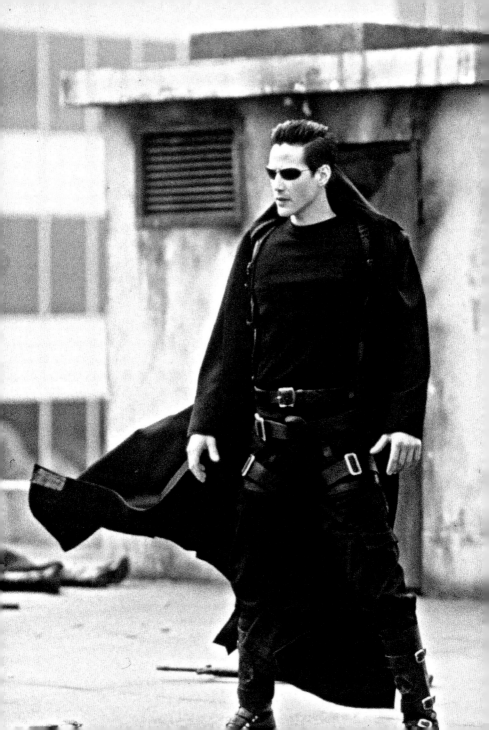

described the two killers, somewhat oxymoronically, as "members of a close-knit group of 'loners' known as the Trench Coat Mafia" shows the need to impose some kind of structure, however bizarre and sinister, on this tragic episode in America's continuous internal debate about firearms.

In the wake of the event, some schools even prohibited students from wearing trench coats, as if to protect against further violence. Sadly, the years that followed saw further in-school shootings, with one killer aged only six, and the uncovering of many plots to emulate the massacre at Columbine. Most recently, America saw the worst school shooting in it's history at Virginia Tech, where 32 people were killed by a single gunman.

page 305:
Keanu Reeves in
The Matrix by
Andy & Larry
Wachowski, 1999.

Preceding pages:
Dune, 1984.

Opposite:
Wesley Snipes
in *Blade: Trinity*,
2004.

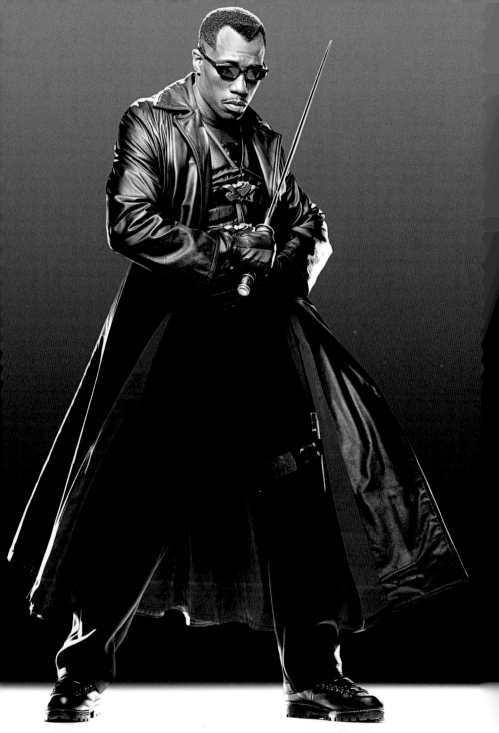

Conclusion

As it approaches its centennial, the trench coat is more vigorous and healthy than at any time since its heyday between the two World Wars.

Initially, its strength came from its practicality: it was quite simply the best garment for the job. Gabardine, from which it was made, was developed in the nineteenth century and refined until it offered clear advantages over the rubberised garments that preceded it. It was strong, light, healthy and remarkably weatherproof. Gabardine was been tested in the hostile climates of the polar regions—it was at the cutting edge of technical fabrics of the day.

This cloth was then tailored into a garment that matched the requirements of a particular situation. In the course of meeting those needs, it developed certain distinguishing characteristics, D-rings, storm flaps, and so on, which made it

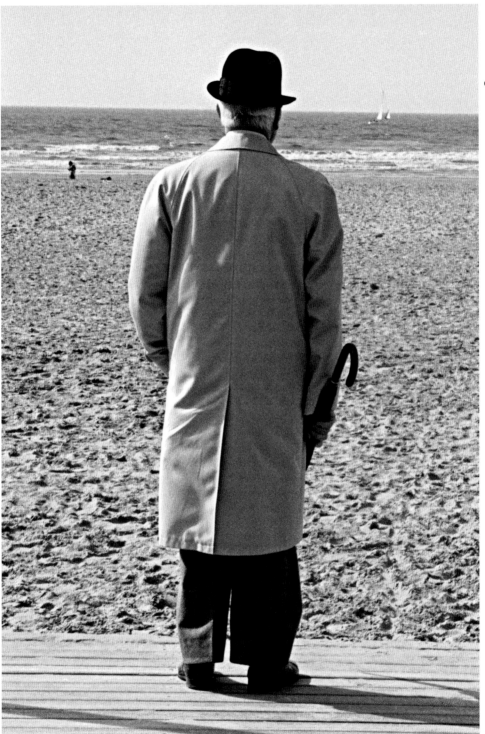

instantly recognisable. Moreover, the experience of the garment was a shared one. The trenches had a lifelong impact on those who survived them, but there was a profound effect on the home front as well. Packages were forever being sent to comfort the troops in the trenches, and even at the distance of almost a century, it is easy to understand the power and poignancy of the trench coated officer with a whistle to his lips, leading a platoon "over the top."

Sheer ubiquity and longevity assured the first generation of trench coats their survival into the latter half of the twentieth century, when the trench finally lost its edge as a technical garment. Although synthetic yarns were used in the construction of some trench coats, the coat was being overtaken by other more modern garments on the battlefield and in civilian life.

Since then, the two seemingly opposing forces of fashion and tradition have ensured the survival of the trench. Tradition preserved the coat—its archaic D rings, epaulettes and all—long after

the military necessity that bred it had passed. Then, the rejuvenation of many long-established luxury and fashion houses, which began during the 1990s, focused the eye of fashion on such classics as the trench coat. Since then, some of fashion's finest and most iconoclastic minds have been at work on the garment, deconstructing it and playing with its proportions and purpose, its cloth and design. If the trench coat is locked into the DNA of some of the world's best-known brands, then some of the world's most inventive fashion designers are coming up with remarkable feats of genetic engineering.

The trench was once a uniform. Now it is a badge of individuality—expressing who the wearer is or wants to be.

BIBLIOGRAPHY

Referenced Works

Austen, Jane. *Northanger Abbey.* London: Penguin Books Ltd; Popular Classics, 1994.

Burberrys of London: An Elementary History of a Great Tradition, London: Burberry Ltd., 1987.

Byrde, Penelope. *The Male Image, Men's Fashion in Britain 1300–1970.* London: Batsford Ltd, 1979.

Chenoune, Farid. *A History of Men's Fashion.* Paris: Flammarion, 1993.

Cunnington, C. Willett and Phillis. *Handbook of English Costume in The Nineteenth Century.* Boston: Plays, 1972.

Daily News, April 7, 1965.

Garrulus, Coracias, ed. *Open Spaces,* Burberry Ltd.

Gentleman's Magazine of Fashion, London: Black Cat Books, 1826-1836.

Hancock, Thomas. *Personal narrative of the origin and progress of the caoutchouc or india-rubber manufacture in England.* London: Keegan, John. *The Face of Battle: A Study of Agincourt, Waterloo, and the Somme.* London: Penguin, 1976.

Longman, Brown, Green, Longmans, & Roberts, 1857.

Levitt, Sarah. "Manchester Mackintoshes: A History of the Rubberized Garment Trade in Manchester," *Textile History,* Vol. 17, 1986.

Mansfield, Alan and Phillis Cunningham. *Handbook of English Costume in the Twentieth Century, 1900–1950,* Faber and Faber, 1975.

"The Evolution of Weatherwear" *International Textiles,* 1944.

The History of Aquascutum. *Celebrating 150 Years of Pure British Style,* ca. 2001.

Vogue, March 1976, pp. 94-95.

Advertisements

Advertisement in the Manchester Post Office Directory, 1854,

Aquascutum Advertisement "How an Aquascutum Coat Fooled the Russians," ca. 1960.

Advertisement in "Aquascutum Service Kit" 1916.

Advertising brochure for Aquascutum coats, late 1930s.

Advertisement for the Expedition Coat, placed in *The New Yorker.*

Trade and Merchandising Catalogues

Barbour Trade Catalogue, 1939.

Dexter Weatherproofs catalogue, 1935.

Army and Navy catalogue, 1939.

PHOTO CREDITS

ACKNOWLEDGMENTS

The Publisher would like to thank Terry Ronca and Matt Walker (ID Public Relations), Gilles Bensimon, Nigel Boekee (Michele Filomeno), Pauline de Boisfleury et Isabelle Sadys (Eyedea), Pernille Coulthard and Greta Pawlowski (Aquascutum), Nicola Easton (Premier Model Management), Pierre Galzin (Archives Jean Gilletta), Laziz Hamani, Sabine Killinger (Elite Models), Gilles Lhote, Isabelle Martin (Corbis), Jessica Marx (Art and Commerce), Alison Jo Rigney and Joan Moore (The Everett Collection), Silka Quintero (The Granger Collection), Lise Seguin (The Kobal Collection), Catherine Terk (Rue des archives), Corinne Nicolas (Trump Model Management), Norbert (No Toys Model Agency), Patrick Lazhar (Model Management), Pascale Duchemin (City Models), Veronique (Marilyn Agency), Véronique Duquesne (Loulou de la Falaise), Morgan Gerle (The Royal Court of Sweden), Babette Hnup (Abaca Press), Robert Garlock (42 West), Anh Duong, Marianne Houtenbos (Arthur Elgort), Bertrand Davasse, Annabel Karouby et Christel Grossenbacher (Cinéart), Katrin Bomhoff (Ullstein Bild), Hannah Wallace and Hiroko (Roxanne Lowit Photographs, Inc), Cindi Berger (PMK HBH), Alison Moore (Patrick Mc Mullan), Fabienne Grévy et Aurélie Allais (AKG Images), Florence Brissieux (Pix Planete), Archives Pierre Cardin, Patrice Stable, Coralie Gauthier (Yohji Yamamoto), Laurence Damoiseau (Pierre Cardin) and Carol Smith.

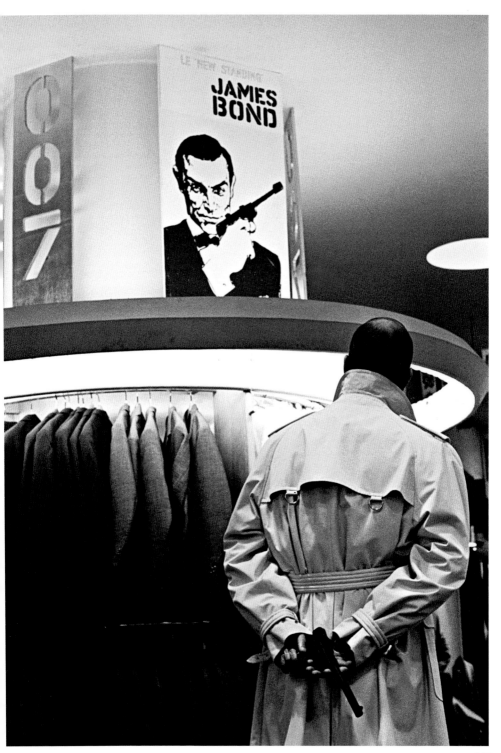